Art Classics

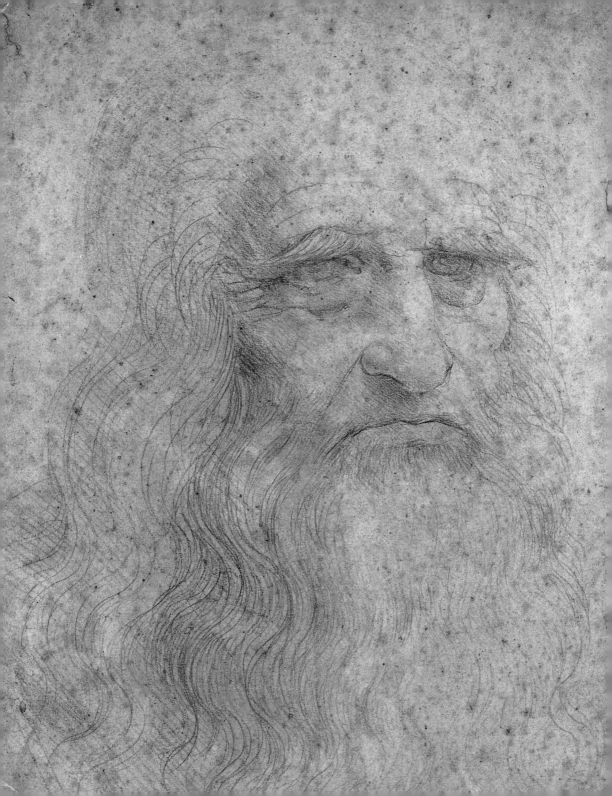

Art Classics

LEONARDO DA VINCI

Preface by Mario Pomilio

ART CLASSICS

LEONARDO DA VINCI

First published in the United States
of America in 2005 by
Rizzoli International Publications, Inc.
300 Park Avenue South
New York, NY 10010
www.rizzoliusa.com

Originally published in Italian by
Rizzoli Libri Illustrati
© 2004 RCS Libri Spa, Milano
All rights reserved
www.rcslibri.it
First edition 2003
Rizzoli \ Skira – Corriere della Sera

2005 2006 2007 2008 2009 /
10 9 8 7 6 5 4 3 2 1

Printed in China

ISBN: 0-8478-2677-5

Library of Congress Control
Number: 2004099908

Director of the series
Eileen Romano

Design
Marcello Francone

Editor (English edition)
Julie Di Filippo

Translation
Miriam Hurley
(Buysschaert&Malerba)

Editing and layout
Buysschaert&Malerba, Milan

Cover
Lady with an Ermine
1488–1490
Krakow, Czartoryski Museum

Frontispiece
Self-portrait
(detail)
Turin, Biblioteca Reale

The publication of works owned by
the Soprintendenze has been made
possible by the Ministry for Cultural
Goods and Activities.

© Foto Archivio Scala, Firenze, 2003

Contents

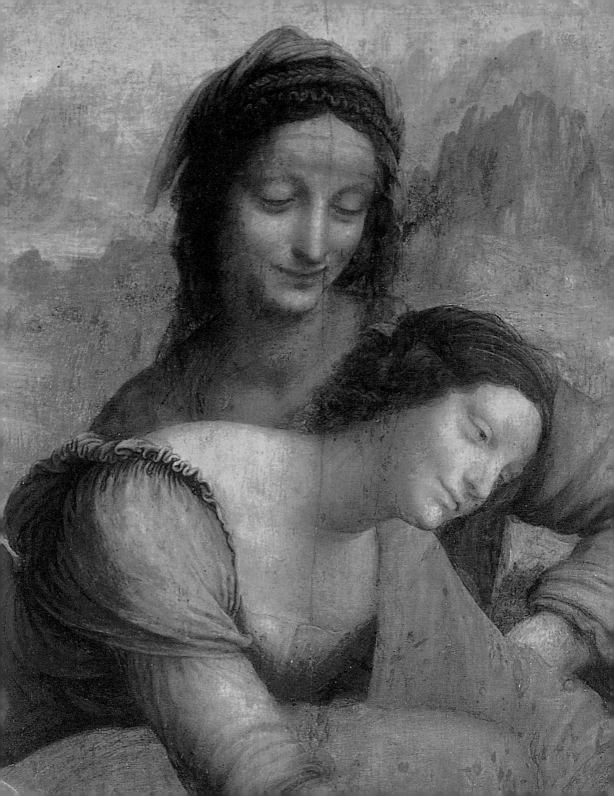

The "Window to the Soul"
Mario Pomilio

I have always believed strongly in the artist who talks about himself. In fact, I think the best interpretations of a text are made in those instances when we can truly enter the intentional world of its author. I have to believe in Leonardo all the more as he showed himself so conscientious to leave us what, though not the first treatise on painting (he was preceded in the fifteenth century by Alberti), was the first of the "poetics" in the modern sense that any artist had ever before attempted to write. It ushered in, along with a "modern manner" of painting, a new spiritual universe in that the feeling of being in possession of a new vision of the world brings with it a total and revolutionary discourse about the tools of its practical figuration.

This is precisely why one of the books that I would most love to work on would be a book on Leonardo illustrated by Leonardo. Mind you, not so much a Leonardo, the painter, commented by the *Treatise on Painting*, but rather his entire *Treatise on Painting* annotated by images from his work as a painter. For one, it would be a way to better acquire our shared cultural knowledge of one of the greatest texts of Italian prose, possibly the greatest of the fifteenth century and the only one that shares its mindset and express methods with Machiavelli's works; that tension and passion of experience to bring to science, that language those nerves and membranes of thought that explode through the energy of synthesis into laws and sentences of "conclusive brevity" (as Leonardo writes) in which we may find the highest expression of Italian Renaissance prose. Making such a book would be a way to place ourselves at the heart of Leonardo's interests and look at him in the way in which he should be regarded. For there is no doubt: though

The Virgin and Child with Saint Anne and the Little Lamb (detail), c. 1510–1513 Paris, Musée du Louvre

7

he was aiming for many things at once with his *Treatise*, he first and fore-most wished to write a "how to see my painting" manual, unmatched for how it lets you come into contact with his problems, introduces you to his ideals of art and educates your eye so that your vision grows in its ability to penetrate his painting, and what's more, to even look at reality with renewed senses.

For example, reading some of his definitions of painting ("Painting is the composition of light and shadow mixed together with the different qualities of all of the simple and composite colors") immediately brings back a straightforward consideration of formal facts, releasing every trace of sentimental dross that could have obscured your view of Leonardo. You read that "he who laughs" must have "raised and separated eyebrows," and you have something that introduces you to Mona Lisa's smile better than the thousands of words that have been said about it. You read his famous "think […]of the effect of the evening on faces […] how much grace and sweetness we see in them," or that "the gentle lights end imperceptibly in the pleasant and delightful shadows," and that "the flesh keeps a little trans-parency,"and "the light that comes down from above takes away all of those parts to which it is shielded by the reliefs of the face, like the lashes that take away light from the eye sockets and the nose and much of the mouth and the chin from the throat." The references immediately multiply and you are better able to grasp the roots of a pursuit that is refined to the limits of the eye's perceptual capacities and is not satiated in changing shadows and contours because another rule (in which there is already the entirety of mannerism), "the shadows that […] cover an irregular body will be of many different darknesses […] as many as the varieties that make the body and its changeable movement." Or perhaps you go to the discussions of colors and you find another quote: "We can almost never say that the surfaces of the bodies lighted either by true color of these bodies […]. If the light that illuminates it is not all of this color"; you also find: "No color that reflects

The Virgin and Child with Saint Anne and the Little Lamb (detail), c. 1510–1513 Paris, Musée du Louvre

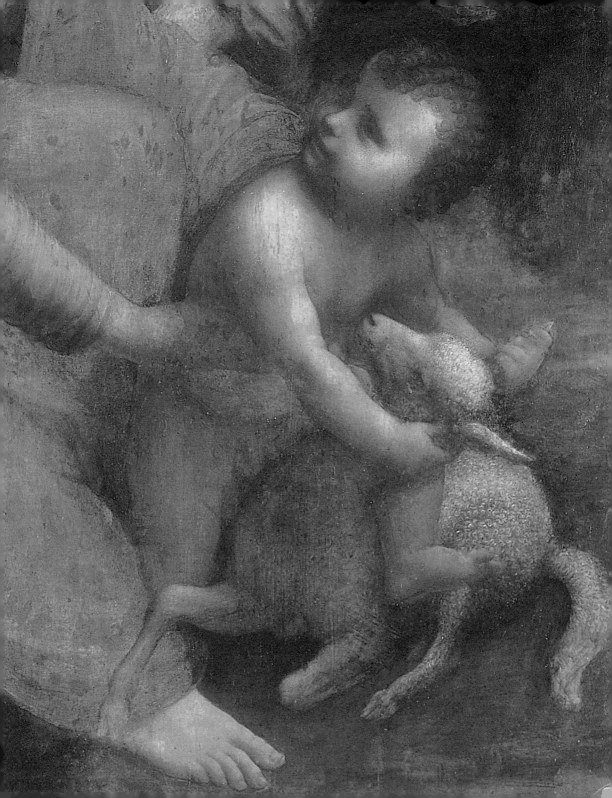

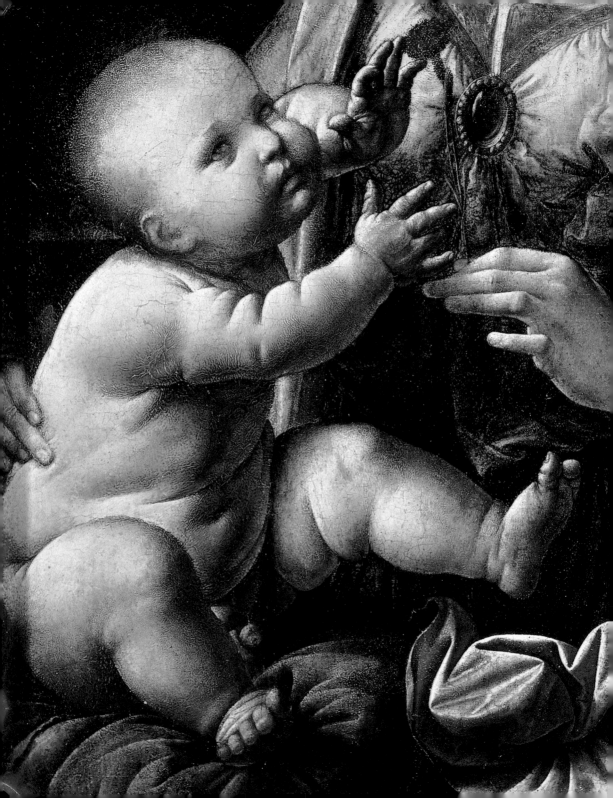

Madonna
and Child
(Madonna of
the Carnation)
(detail),
c. 1470
Munich, Alte
Pinakothek

in the surface of another body colors this body with its own color, but it will be mixed with competitions from the other colors reflected that fall in the same place," and immediately from painting to painting you are able to look with a strengthened sensibility at the changing greens, blues, pinks, browns of the flesh, on clothes, on the surrounding elements and, for instance, you take in the differentiated melting of light on the figures in the *Annunciation* in Florence. Or consider the rules of the "multiplication of the airs" and this in particular: "All bodies together and each itself fills the surrounding air with its infinite similitudes," and you have within your grasp Leonardo's magic, that lyrical multiplication of references (think of the *Virgin of the Rocks*) resolved in a lofty amalgam of tonal assonances. Then there is the massive amount of observations about the "demonstrative acts" and the movements of the limbs, the muscles, the positions of the bodies. As you read them, you have a thousand encouragements to follow the infinite care that Leonardo used to vary expressions and movements and his effort to place the "passion" and the "act" in precise relationship (because he said, again predating mannerist taste, "that figure is most laudable that in his act best expresses the passion of his soul"). You also find in the *Treatise* the precepts for plants, which Leonardo wanted to be here yellow-green, there blue-ish, and which should be "much darker […] in that part that ends in the air," and which it is suggested to make "as you see them at night with little light because you will see them the same as a dark color pierced by the light of the air": and your eye alights on a thousand details and better enjoys the "most beautiful greens" that any painter has ever given us in the very delicate inlay of the leaves behind the portrait of Ginevra Benci in Washington, and the extraordinary tonal variety of the trees lined up in the background of the *Annunciation*. And finally, if you want to sit down to contemplate the inexhaustible fascination of Leonardo's "aerial perspective" on the great air saturated with blue in his backgrounds, his mixing of white and pink, you are again satisfied in the *Treatise* and you

read that "great distance encompasses much air within it" and for the great quantity that we find "between the eye and the mountains, that seem blue almost the color of the air"; and "the country landscapes have all the more blue the further they are from the eye and this blue becomes lighter the closer it gets to the horizon," but if the horizon has no mountains "the sky must become lighter the more you make it finish low"; and if "the sun reddens the clouds on the horizon, the things that are dressed in blue due to the distance will be affected by this blush"; and we must also "put in [...] the things so far from the eyes that they are only spots, not finished, of confused boundaries" and make them "selected when it is cloudy and high in the evening."

We could go on like this forever. Yet we realize that despite all of this, the problem of Leonardo is still open once we try to go from the results to the premises and to the type of relationship that he institutes between practice and theory and, more widely, between art and science. Because science serves first and foremost for defining the methodological rigor that Leonardo expects of the painter. It also immediately presents the problem of a scientific notion of nature. It is precisely this, this "nature" elevated to science and all the more loved the more it reveals the mathematical necessity of its behaviors. This places it at the center of his interests as a thinker and it is the very foundation of his conception of the world, making it the primary theme of his artistic pursuit and almost the very content of his vision as a painter. There is more still, evident when we evaluate the extraordinary innovative quality of this conception and vision, which in addition to possessing the fascination of all of the great beginnings and makes Leonardo's "naturalism" or "scientism" the moment of birth of modern science, if for nothing else than for the clarity with which he intuits the relationship between phenomenon, law and experimental results; he brought about a true revolution which in some ways is still going on, within the eternal problem of the relationships between art and reality. For the first time with his scientism, there is rather than a fact to reproduce, a fact to investigate and through which an insatiable

experimentalism ceaselessly gathers new expressive methods or, all together, tools for investigating reality in an effort which would end up a bit dispersive, yet this is the aspect of him that brings us closest to him.

It is interesting and it is telling: we talk about the painter and the mind goes with the thinker and no matter how much you try to stick to your topic, you feel Leonardo's message still in the center of our alternatives, if for no other reason that this dilemma between science and art that he passed on to us, which is still completely ours and for which, if we cannot use his answers today—in that a synthesis that appeared to fit harmoniously to him seems less and less tenable to us today—the premises—experimental—are an inalienable part of our cultural mindset—from which he took the steps and inspirations which he introduced into the arts.

Having said that, I do not wish to fall into the common trap of removing Leonardo out of his time. He was indeed a man of his time, if only in so much as he brought to completion a century of reflection about art. Yet, while at first sight he seems to take up the precept of art as imitation, which he was handed down to him by centuries of long tradition that flowered in fifteenth century pursuits, you will soon recognize that accepting it and saying, for instance "painting represents the works of nature to the senses with more truth and certainty" does not at all mean that this is all there is to it for him. On the contrary, it puts more accent on that "truth and certainty" and wanting, for one example, to perfect the fifteenth-century experiments on perspective and study three of these—the diminishing of bodies with distance, of colors and of aerial perspective—to realize the superb dream of a full figurative mastery of reality. It means more than anything embarking on the most adventurous of explorations because "nature is full of infinite reasons that there never were in experiences," without the science of these reasons "the painter [...] is no more than a mirror which copies slavishly everything placed in front of it and which has no consciousness of the existence of these things"; he therefore wishes to

13

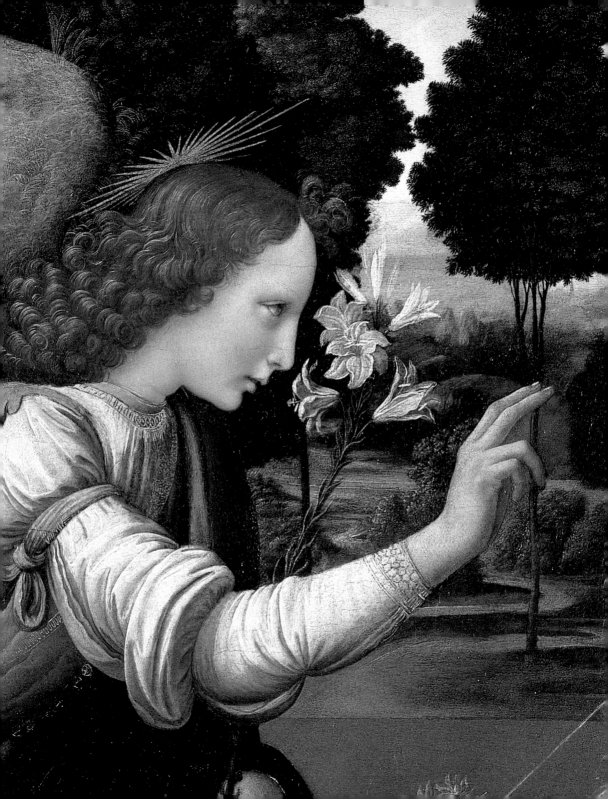

go outside of a merely reflected nature, to the inside of a nature explored in its causes, to demand an experimental method in view of a study that, though it closes within itself, it leads him to science, and from there to art, it remains coherent everywhere. In other words, he wants to open a perpetual exchange and translate the problems of imitation and art everywhere into problems of consciousness and science (and, of course, vice versa). From the question of how to imitate we arrive at the other question of how we see and from here we come to the "last principles" of geometry, physics and especially of optics and the collection of laws that investigate and the visual universes that it discovers cultivates the magnificent, impossible ambition of translating them into complete figurative experiences.

So how is it that from all of this, he ends up a painter who is so lyrical and, I would say, subjective, impalpable, best able to create visions suspended in zones of near unreality? Of course, this comes at least in part from his neoplatonic traces that, while not conflicting with his scientism (in the same way that the two coexist in the civilization of which he is a part) guided him in fixing in "proportional harmony" the "beauty of the world" and the "ornaments of nature." It also has to do with a still intact wonderment of nature, which calls upon the man of science now ("Every natural action is made by shortest route [...]. These are the miracles!") and in the next instance, the writer ("The moon, slow and grave, how is the moon?") and in everything the artist remains a guarantee of the poetic edge of Leonardo's scientism. It depends in the first place on the quality of this scientism which, in wanting to penetrate the last principles of things and give you a nature that is no longer immediately a portrait, but is mediated through its internal behaviors, almost wears out things in view of the causes, in the eagerness to present you the seen and the indiscernible together, spiritualizes almost to a point of excess and makes Leonardo's eye truly a "window to the soul" as he liked to call it.

This is the fact of the matter: that gradually as Leonardo explores the

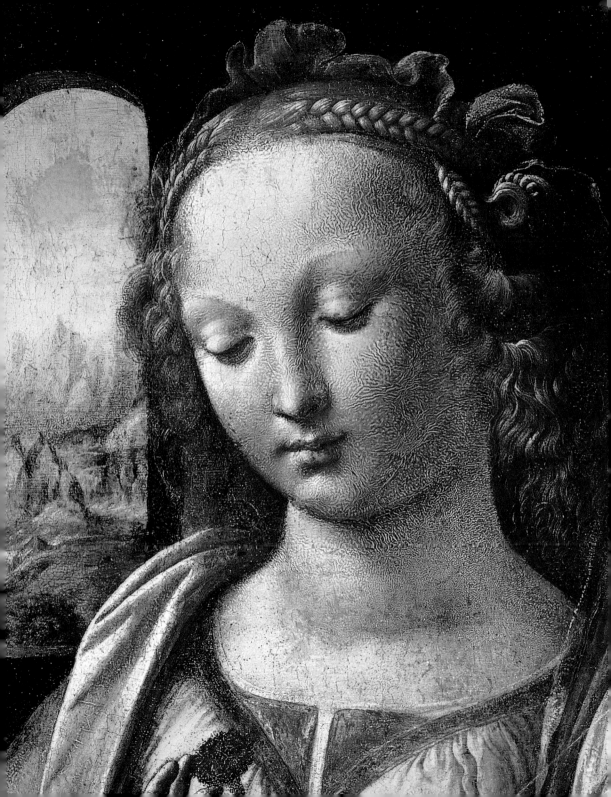

laws of optics he discovers the entirely phenomenological quality of everything that happens under our eyes and on the one hand he realizes its hopeless irreproducibility both as relief and as perspective (and we know how much he studied the differences between perspective image and retinal image—the so-called marginal aberrations—and the reasons for which the "painting cannot appear distinct as natural things"), and on the other that reality does not offer itself on its own but only through the effects that our eyes take from it. These effects are light and dark, colors and perspective itself: optical effects or illusions, that is to say, that can be changed infinitely depending on the points of view, distances, lights, hours, for which not only the "things seen from afar are disproportional," but from one moment to the next "the same thing seen will show itself to be of different sizes." As such, the more his study tries to mathematicize and objectivize, the more it discovers the subjectivity of our sensations. The more it tries to act on an absolute mode of representing things, the more it feels our visual faculties as relative and must recognize that the "science of painting" consists in the end in the "predicaments of the eye," or in the words of a modern perspective, that the relationship of the eye with the world is a relationship of the spirit with the world of the eye. This does not mean, that we mean to talk about a relativism that was totally alien to Leonardo's mentality. We merely mean that for how he was oriented and the solutions that the laws of optics and the studies on perspective set him, leading him to contemplate the framework of a system of relationships referenced to our eyes, his attempt to make the representation of the outside world systematic and scientific had necessarily to be solved in an expansion of the sphere of the subjective and throw open the doors to the self of the observer. While it is typical of medieval painting and a large part of fifteenth-century painting that the scene depicted lives within itself, complete in a system of internal relationships and in a precision of meanings that make them seem indifferent to the presence of the person looking at it, even when perspective

19

was attempted or achieved (it is really a devotional event with God as spectator and the viewer as witness), possibly the essence of Leonardo's modernity lies in the fact of having turned it into an emotional event in which you are also a protagonist in that you are not excluded from it. On the contrary, he pulls you into it and makes you an active part, making you feel almost as if it were waiting to be completed in your eye—and in your soul. It may be in this, in the new role given to the spectator, that we have the primary reason behind the kind of Copernican revolution that the appearance of Leonardo brought to painting; the quiet and lofty conversations in which he involves us and in the same margin of mystery that we usually attribute to him and that actually comes, rather than so much from symbolic residues, from his offering himself to the intervention of our interpreting spirit according to an ever-changing fabric, susceptible to new impressions (and don't the evocative power of so many of his things even make us think a little—and without too many historic judgments—of the famous spots on the walls and clouds that Leonardo suggested the painter look at because these "awaken the genius of the painter to new inventions" and "this is like the ringing of bells in which one can understand whatever one wants to")?

Yet, there is another reason for all of this. If we consider that Leonardo's universe was not a still universe. It is always surprised in motion or in the act of changing and the feeling looms that the being is within time and it is making itself always changeable and an unrepeatable becoming. "Look at the light," he says, "and consider its beauty. Blink and look at it again: what you see was not there before and what was there is no longer." We understand from this insertion of the concept of time in the traditional pictorial concept of space and the notion of a nature in which everything flows and diversifies ("The water that you touch from the rivers is the last of that which went and the first of that which comes: such is present time"), the importance that Leonardo puts on the issue of "mutation," the unstable, the undecided, the fleeting, of that which "transforms as it goes" and all

that makes it so that in his paintings the being appears to be dissolving in an epiphany of becoming, made as it is by the moments of the loftiest suspension, absolutely perfect moments, instants, yet in which awareness looms of the ephemeral quality of the actual, beautiful moments stopped on the point in which the passing of the hour sends them to be lost, absolutely harmonious presents, but as if they were broken by the feeling of their unrepeatability. "Oh marvelous science," says Leonardo of painting in an exclamation in which there is all of the Renaissance's dream of perfection and all of its fragility "you keep the fleeting beauties alive […] which are constantly changed by time."

Leonardo's entire œuvre starts from the awareness of the inconstancy of phenomenological reality, comparable to the very strong awareness of the scientist of the inconstancy of physical reality. Just as the scientist intuits that the rivers, gnawing the valleys, continuously change the landscape or that nature takes pleasure "in making continuous lives and forms," the painter was highly sensitive to the infinite variety that the action of time brings to the appearance of reality. It is in this key of a suspended vision and as poised between two bats of the eye and already ready to disintegrate, I can come more often to Leonardo's painting and feel the why of the ineffable fleetingness of the expression of his faces, of the shadings and incompleteness of his landscapes, of his explorations of shadow, of his interest in the gesture and the state of mind which in manifesting itself seems already about to dissolve, just as in his preference for the lights of dawn and dusk and the backgrounds turned to blue and the moments in which the atmosphere is most indecisive and impalpable and the fleeting essence of the "beauty of the world" is most evident and the quality that is both lofty and fleeting with the joy that we get out of it. Almost as if, in fixing in an absolute expression the perfection of an hour that is just about to disintegrate, it is as if he wanted to save it from the trap of time, this "fast predator of human things," which would soon have "undone" it.

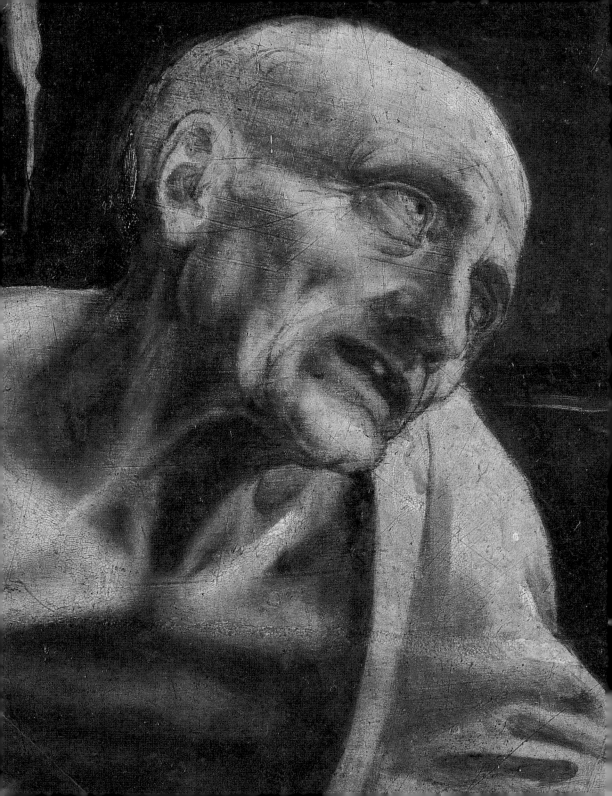

His Life and Art

Leonardo Da Vinci's name evokes the concept of genius in the public imagination. He lived in an era (despite the invention of printing, the discovery of the "new world," the "rebirth" of the arts, and the concept of "man at the center of the universe"), in which the contrast between his aspirations and the means and tools available to him reveal all of his humanity and uniqueness to us today. Cesare Luporini (*La Mente di Leonardo*, 1953) describes the split: "The issues that he explored and on which he worked—nature, science and its method, the experiment, the machine, utility for the good of all men, the cognitive and realistic character of art, the relationship between art and science—were laden with the future in relationship to his times. These would be some of the decisive issues to form the modern world." Leonardo was ahead of his times.

Giorgio Vasari, biographer from Arezzo and author of *Lives of the Most Eminent Painters, Sculptors and Architects*, has passed down the image to us of a man in whom "genius combined with beauty, grace and strength. So many virtues in one body!" But then he quickly adds: "For he set himself to learn many things, and when he had begun them gave them up. In arithmetic, during the few months that he applied himself to it, he made such progress that he often perplexed his master by the doubts and difficulties that he propounded. He gave some time to the study of music, and learned to play on the lute, improvising songs most divinely." Recent studies have also revealed an interesting fact. The artist did not know how to do sums; he could not solve the simplest mathematical operations. He also could not read Greek texts and in all likelihood he read Latin texts only with the help of some skilled friends. Yet, this man's great curiosity, his extraordinary ability to visually analyze natural phenomenon transposed through figurative representation, seems ultimately to be one of his "genius" qualities. This bring us to the core of this essay: his

painting. Leonardo surpassed fifteenth-century figurative tradition in theory and artistic practice. That tradition was founded on the method of linear perspective alone, which he considered insufficient. Nature should be represented through the mental process of the artist who applies an "aerial perspective" to it, as he well explained in his *Treatise on Painting*. This essay very likely dates to his time in Milan and was taken by some of his students, such as Cesare da Sesto, as a manual of rules. It clearly demonstrates how Leonardo considered painting to be above any other artistic expression.

The chronological ordering of Da Vinci's works is based mainly on style because we have few documented facts and many of them are about works that were never finished or have been lost. Today we can use modern diagnostic techniques on the paintings (radiography, reflectography and infrared photography) that show us new details hidden from the eye by paints in order to study the origin of the works and sometimes their chronology.

His grandfather Antonio, in whose house Leonardo spent his early childhood, brings us the news of his birth. "My grandson was born, son of my son, Ser Piero, on April 15 [1452] on Saturday at three in the morning [corresponding to our 10:30 p.m.]. He was the illegitimate son of Ser Piero, notary and part of a wealthy family of land owners in the Empoli countryside, and Caterina, a peasant who would soon thereafter marry a certain "Achattabriga di Piero del Vacca from Vinci." The terse note we have about the mother comes from Leonardo's own hand and dates from a visit she made to her son in Milan: "Caterina came on July 13, 1493." We do not know with certainty when Leonardo moved to Florence. It may have been after his father, who was already there in 1464, the year in which his first wife, Albiera di Giovanni Amadori, died and was buried in Florence. The first documented news we have is an annual payment made in 1472 to the Compagnia di San Luca, an association of

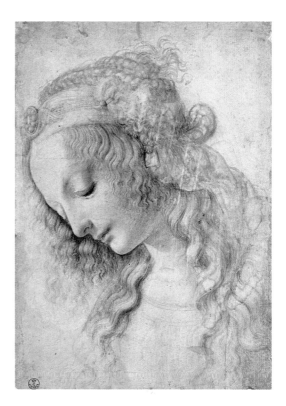

Female Head
Florence, Galleria degli Uffizi,
Gabinetto dei Disegni
e delle Stampe

Florentine painters, a predecessor of the sixteenth century Accademia delle Arti del Disegno. Belonging to this association was a common practice among those practicing art in the city. The Compagnia had existed since the fourteenth century, was hierarchically structured, had its own statute that the members had to respect and an essentially religious character—with special devotion to Saint Luke the Evangelist (he was also a painter in the Christian tradition)—that took the form of artistic practice accompanied by religious exercises. The Compagnia di San Luca should not be confused with the Arte dei Medici e degli Speziali, as this was a full-fledged guild in which membership required a registration fee. Of course, at this point, Leonardo was in his twenties and his training had, strictly speaking, already been completed at Verrocchio's multidisciplinary art workshop. However, two documents from the spring/summer of 1476 show that he was still working with this artist. "Lionardo di Ser Piero da Vinci is with

Andrea del Verrochio." These papers are not about artistic events or census statements, but a condemning note on his sexuality, an anonymous report to the *Ufficiali della Notte* of the city of Florence, a magistrature that oversaw proper citizen conduct, that Leonardo and three others were accused of sodomy with a certain Jacopo Saltarelli. To be true to the facts, we should note that the report bears an acquittal of the accused in the margins.

We hear, again from Vasari, how Ser Piero realized his son's great talent for drawing and placed him in the workshop of his good friend, Verrocchio. This likely happened around the mid-1470s when Leonardo was the right age for entering a workshop (this was between nine and twelve of age). Here he could learn all of the special skills that a leading Florentine studio such as that of Andrea's had to offer. There was reason that the greatest masters of the late fifteenth century revolved around Verrocchio's workshop, including Sandro Botticelli, Domenico Ghirlandaio, Pietro Perugino, to whom were added the permanent students Leonardo and Lorenzo di Credi, and the sculptor Francesco di Simone Ferrucci. The figurative language that developed in this multidisciplinary environment could accurately be defined as "Verrocchiesque" with the result that we now have difficulty distinguishing Verrocchio's works from those of his students. The emulation of his disciplines and collaborators of the workshop master's style was not something looked down upon between the fifteenth and sixteenth centuries. It was not considered a matter of having little skill as it was this that made it possible to accept commissions for many works and complete them in the agreed-upon times, thanks to the stylistic uniformity of all of those who worked on it. In addition to his regular disciplines of painting, sculpture and drawing, Verrocchio's versatility took the form of carpentry, casting and mechanics in general. The work of the copper ball on the cupola of Florence's

Duomo dates to 1471. A worthy epilogue to complement the city's emblematic monument was made by Verrocchio. Leonardo would participate in the event, which he would not forget to note many years later (about 1510) on a piece of paper kept in Paris. The basis for the master's teaching method was drawing, a technique shared by all artistic disciplines. In Verrocchio's workshop, a special type of drawing was used: "black and white" pen on linen canvas (*rensa*). This practice was adopted by sculptors who used earth models clad in "filled-in" cloths. Drawing was the basic groundwork of the artistic path, and was considered the representation of movement and nature. It is not surprising that the first work dated by Leonardo was a pen and bistro (now in the Gabinetto dei Disegni e delle Stampe at the Galleria degli Uffizi) portraying on the *recto* a mountain landscape in the upper left corner of which the artist, with his characteristic left-leaning handwriting, caused by his being left-handed, wrote "di' di s.ta Maria

della neve addi 5 d'Aghosto 1473" (Santa Maria della Neve on August 5, 1473). Our attention is not captured by the small castle perched on the left-hand ridge but by the depiction of nature with its large waterfall that sprays on the valley beneath; it is almost as if we can hear its roar. Verrocchio must have quickly realized his pupil's talent for landscapes as some of the backgrounds of the compositions he prepared in the workshop are ascribed to Leonardo (*Madonna with Child and Angels*, London, National Gallery; and two *Madonnas with Child* now at the Gemäldegalerie in Berlin). Along with this specialty, Leonardo's talent for portraying animals gave Vasari another anecdote. Ser Piero, again, this time acting as an intermediary between a country man who wanted to have a round piece from a fig tree that he owned painted. After Leonardo had had it turned, he painted on it a "horrible and fearful animal." The animal's realism was so great that the painter's father realized that rather than give the round piece back to its

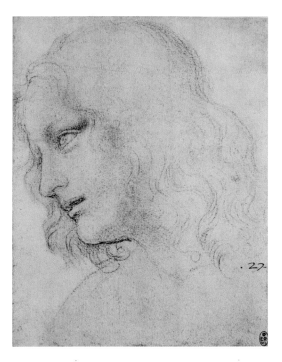

legitimate owner, he could give it to some merchants who sold it to the duke of Milan for three hundred ducats. Maybe Leonardo managed the beast so well because of the love he had for animals. As Vasari tells us, in passing places where birds were sold "he would take them out of their cages, and paying the price that was asked for them, would let them fly away into the air, restoring to them their lost liberty."

His surviving drawings of animals evidence this passion that we find not least in his painting. We need only mention the vivacity of the little dog and the fish in the painting of *Tobias and the Angel* in the National Gallery in London, which, though attributed to Verrocchio's workshop, saw Leonardo's hand in these two animals; then there is the tremor of fear that raises the fur of the ermine in the *Portrait of Cecilia Gallerani*; not to mention the serpents in the head of *Medusa* (precursor to the one by Caravaggio that is now in the Uffizi), which at the time, according to Vasari, was in

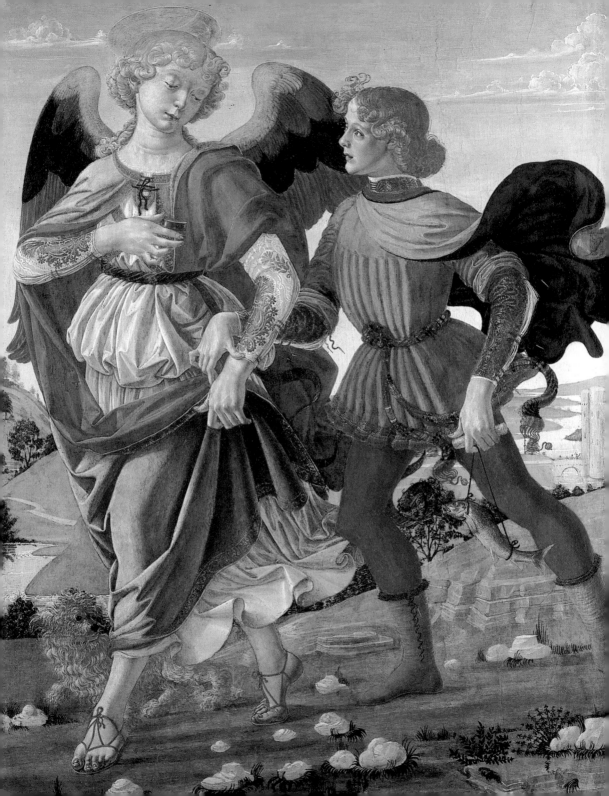

Cosimo I's Guardaroba at the Palazzo Vecchio, but has unfortunately been lost.

The *Madonna of the Pomegranate*, now at the National Gallery of Art in Washington, is Leonardo's oldest pictorial essay. It clearly shows his origins in the Verrocchiesque environment, so much so that in the past it has sometimes been attributed to Verrocchio himself or to his very faithful student Lorenzo di Credi. Yet, there is a distinct fineness in the execution of the delicate and precise touch, a certain transparency of the flesh that can only be ascribed to Leonardo among Verrocchio's students. Then there is his manner of painting the draping of the clothes of which we find precise examples in the studies on canvas mentioned above. The work is from the end of the 1460's (around 1469: a period in which Andrea took a trip to the Veneto, possibly bringing his young pupil with him as is shown by the style close to that of Bellini, whose United States painting Marani recognized.

The same type particulars are found in the so-called *Madonna of the Carnation* (Munich, Alte Pinakothek) which must have been painted immediately after the Washington Madonna and which strongly reflects the Verrocchiesque environment, as shown by the yellow drapery in the foreground. In this painting, the young painter experimented with oil technique to compete with Flemish painting, of which some influences had reached Florence. The vision is highly effective as Leonardo succeeds in creating a translucent surface and giving the light mobility.

The aura of mystery surrounding Leonardo's life is partly due to the fact that many of his works have been lost. Attesting to the existence of some of these we have studies done by his hand or reflections of them in paintings attributed to his followers. Of others, we only have the news that sources give us. We already mentioned the "fig tree wood" and the head

of *Medusa*. According to Vasari, Leonardo also painted a watercolor cartoon of the *Original Sin* for a tapestry to be woven in Flanders for the king of Portugal, which was never completed. Though, in Vasari's times, this cartoon is mentioned in the house of Ottaviano de' Medici; and an angel that, like the head of Medusa, Cosimo had a work "with the head of an angel raising one arm, which is foreshortened as it comes forward from the shoulder to the elbow, and lifting a hand to its breast with the other." There was also a drawing of Neptune in the sea made for his friend Antonio Segni, which was so realistic that it seemed alive; portraits of Amerigo Vespucci and "Scaramuccio Capitano de' Zingani." Though the two portraits were lost we have an idea of the Leonardesque conception of this painting genre at that time, by admiring the so-called *Ginevra de' Benci* (Washington, D.C., National Gallery of Art) in which the Verrocchiesque type of the *Lady with Bouquet*, now at the Museo del Bargello in

Florence, is skillfully mingled with Flemish painting technique.

If we accept the hypothesis that the portrait was a commission from the Venetian ambassador Bernardo Bembo, who was platonically in love with Ginevra, it reflects the environment of the Florence in which Leonardo found himself working. It was a city in the full bloom of the Laurentian era, which was equally humanistic and aristocratic. Lorenzo de' Medici, better known as The Magnificent, upon the death of his father Piero in 1469, assumed the leadership of the affairs of city government and quickly became a commissioner and patron of artists. Lorenzo was a friend and protector of the Ginevra-Bernardo couple, to the point of sending the woman two consoling sonnets after the final departure of the ambassador. It was no secret that Verrocchio was one of Lorenzo's favorite artists. He made the tomb for his father and uncle Giovanni in the church of San Lorenzo. He probably made a *putto* with the dolphin for the fountain in

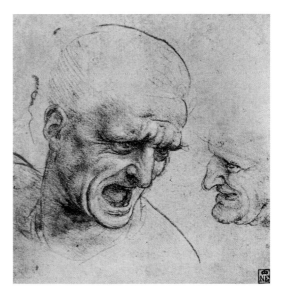

Study for two heads of soldiers
c. 1503–1504, for the painting
Battle of Anghiari
Budapest, Szépmüvészeti Museum

the garden of Villa di Careggi and the relief representing an ideal portrait of "Scipione" with armor and helmet with magnificent ornamentation, in whose creation Leonardo likely took part.

According to Anonymous Magliabechiano —who joins Vasari as an invaluable art history source—even Leonardo passed through Lorenzo de' Medici's famous garden (*Giardino di San Marco*), a kind of school of young painters, sculptors and noblemen, whose custodian and director was the sculptor Bertoldo di Giovanni. The garden was located in front of the Dominican convent of San Marco. Inside there were antique sculptures and marbles, sarcophagis and fountains, the perfect place to practice sculpture.

On January 10, 1478, a few months before the Pazzi conspiracy, in which Lorenzo's brother, Giuliano, was murdered, Leonardo received an assignment from the Priors of the city of Florence with a formal, solemn document, as were

the Deliberazioni dei Signori e Collegi (currently preserved in the Archive of the State of Florence), to paint the altarpiece for the chapel of the Palazzo della Signoria dedicated to Saint Bernard. The subject of the painting was not specified. The Florentine government wanted to replace the existing altarpiece painted by Bernardo Daddi in 1355, which had become obsolete and too far from contemporary fashions, with one that would reflect contemporary tastes. A mere seventeen years earlier, the commission had been given to Piero del Pollaiolo, another prominent artist in Florence's late fifteenth-century art scene. He, however, refused it. On March 16, 1478, Leonardo received twenty-five large florins for the job, a considerable sum, and a sign that the artist had already undertaken the work in some way, probably by drawings, though nothing has survived. This commission, though it is unfinished, is significant because it serves as an important sign of trust in an artist who was still starting out, a young talent which

had not yet been revealed. The work was later given to Ghirlandaio, but was only completed in 1486 by Filippino Lippi.

The *Annunciation* in the Uffizi was also conceived under Verrocchio's influence, as evidenced in the oval jewel that hangs from the triple-loop necklace, hidden under the current paint (in addition to the oft-mentioned comparison between the marble base of the lectern for the tomb of Giovanni and Piero de' Medici, made by Verrocchio in the same time period in San Lorenzo). The jewel's existence was revealed by infrared studies made on the painting in 1999. This jewel can be compared to many pendants worn by women or Madonnas on paintings and drawings that came out of Verrocchio's workshop. We can look at modern studies on works of art on the subject of this piece's Verrochioesque origins to show how much the manner of approaching art history has changed. We cannot fail to notice the fact that the affinity of the nature portrayed in the *Annunciation*

and the nature invisible to the bare eye in the *Baptism* (known through technical studies performed on the painting) is a solid basis for the close dates of the two works, as well as evidence of a conception of the same artistic climates. We should add a point about the original destination of the *Annunciation* as a quite striking fact bears upon it: the silence of the sources. As Antonio Natali has argued, it is likely that the Olivetana church was not its original location because Vasari's silence could indicate that the painting was not found in the sixteenth century in this monastic complex. Vasari knew about Leonardo's participation in a work by Verrocchio, such as the *Baptism*. Would he have failed to mention a painting that was completely his? The omission seems strange, particularly considering that Vasari had friendly relationships with the monk, Don Miniato Pitti, who was also prior of that monastery and who Vasari quotes several times in his autobiography, calling him his *amicissimo* (close friend).

The *Baptism of Christ* by Verrocchio is now kept in the Uffizi and is the only painting that we have discussed so far of which sixteenth-century sources speak. According to a famous Vasari story, once the master saw the angel painted by Leonardo he decided to stop practicing this art and dedicate himself exclusively to sculpture: "Lionardo's angel was better than Andrea's figures, which was the cause of Andrea's never touching colors again, being angry that a boy should know more than he." The work has often been considered emblematic of the teamwork done in Renaissance artist workshops. However, more recent criticism shows how Leonardo's work should be considered not the first collaboration of a young artist in his master's workshop but as the completion of a painting, whose fates should be reconsidered. The *Baptism* may have been started by the master and his students (Botticelli's name has been suggested for the angel painted next to Leonardo's) a few years earlier and then completed at the end

of the 70s. In that era, Leonardo had his own specific artistic personality. The pictorial shaping of a different quality level is clear at even a cursory glance. The sight of the beautiful and expertly executed angel shown from behind but with the head turned to the side and obliquely from below to look up at Christ, constitutes a unique case for mastery of the anatomy, the human structure and space in contemporary Florentine painting. The imitation of reality that Leonardo affected in the background landscape can be taken as emblematic of his way of conceiving painting: an open window, beyond which the eye glimpses the image of a world perceived with such a level of simulation that it could be taken for a real view.

Recent scientific analysis undertaken during the last restoration (1998) revealed some interesting things about this painting: in Christ's face we can see the use of a finger tip to soften color transitions on his skin (as in the portrait of Ginevra de'

Benci). It also showed the trace left on the drapery of the Leonardo angel by the fabric of the clothes worn by Leonardo, which inadvertently brushed the newly laid oil and impressed his real life mark.

Before leaving Florence for Milan, Leonardo proved the maturity and artistic development he had achieved in two monochrome masterpieces, which, however, remained incomplete: *Saint Jerome* (Vatican City, Pinacoteca Vaticana) and the *Adoration of the Magi* (Florence, Galleria degli Uffizi). The unfinished nature of the two works gives us valuable information about their genesis. The first is an example of the knowledge he had achieved of human anatomy and its relationship to surrounding space "within which the kneeling saint is three-dimensionally placed, almost as if it were a portrayal of a historic sculpture that measures with its arts all of the spatial directions (how can we fail to think of knowledge of some ancient models

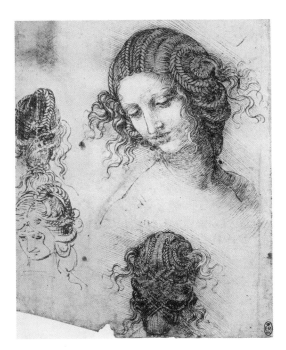

like one of Niobe's children)" (Marani).

The *Adoration of the Magi* is a summation of the great progress achieved by the artist on nature and the motions of the human being. In this piece, Leonardo innovates in these ways the figurative canons of the sacred event to place himself in a groundbreaking role in the late fifteenth-century Florentine artistic scene, more current than Verrocchio, Lorenzo di Credi, Botticelli or Filippino Lippi. The monks of San Donato a Scopeto would give this same commission that Leonardo never finished fifteen years later to Lippi. In the human vortex created in the painting, in which almost all of the figures move, the bodies show a composition of the masses in Ghiberti's style, a flexibility following Masaccio's ideals and Donatello's mobility; the greatest artists of the fifteenth century are brought together in a single scene.

It is clear how much Leonardo thought about this composition by his many studies and preparatory drawings, one of which,

kept in the Gabinetto dei Disegni e delle Stampe at the Uffizi (*Studio di Prospettiva*, inv. 436 E *recto*) shows the pursuit of a prospective definition of the space for the characters and a majestic architectural construction that we intuit through the inter-weaving of lines. Leonardo was twenty-nine when he conceived this painting. He was in full artistic vigor; the comparison is natural with the great figurative revolutionary that was Masaccio at the beginning of the century, who died at only twenty-eight.

The small *Madonna Benois* is from these years. The critic Bernhard Berenson (1916) scathingly described it as the portrait of a bald, toothless little girl. Regardless the different existing copies, all of which can be traced back to the Florentine environment, indicate the composition's immediate success.

It was likely in September of 1482 that Leonardo moved to Milan to the court of Ludovico il Moro, who was elected duke only in 1492, but had in fact exercised his power since 1480. This man's ambition turned the Milanese court into one of the richest and most fertile in Italy, to be able to compete with Florence. It was a refined center of humanist culture and a center of attraction for scientists, artists and writers, suffice to mention the names of the architect Donato Bramante, the mathematician Luca Pacioli and the musician Franchino Gaffurio, possibly painted by Leonardo in a work preserved in the Pinacoteca Ambrosiana.

According to the sources, Leonardo was invited to Milan by Lorenzo the Magnificent, along with Atalante Miglioretti, an expert player of a silver lyre in the shape of a horse's skull that he made himself (we have already mentioned that Leonardo was also skilled in music and song). Yet, a letter included in an unsigned edition in the *Codice Atlantico* tells us about the actual assignments that Leonardo hoped to receive from the gentleman from Milan: works of engi-neering, military art and, last but not least,

paintings. Leonardo, the theoretician and man of science, was born in this environment. The period in which he remained in the Sforza court amounted to eighteen years and was full of assignments. He worked on constructing magnificent sets and mechanical devices for jousts and court shows; he designed costumes for parties and tournaments and even came up with poems, fables and rhymes. He was what you would call a perfect courtier.

In term of work in Milan, on April 25, 1483 he received an assignment, with the siblings Ambrogio and Evangelista de' Predis, to paint the central panel of a grand and varied altarpiece to be placed in the chapel of the Concezione in the church of San Francesco Grande. There is still a Gordian knot to be untied to explain why the subject portrayed in the *Virgin of the Rocks* in the Louvre, with which this first commission is generally identified, does not correspond to that requested by the members of the brotherhood of the Concezione. The

notarial contract, which was for that matter very detailed, specifies that the central painting of the total system of the altar should have a centered form and include the Madonna with child surrounded by a group of angels and two prophets. The two side paintings were to be rectangular and portray four angels in the act of playing music and singing. Then there is the fact that subsequent documents name Ludovico Il Moro as one who could induce members of the company to give the painters an increase over the originally agreed upon payment. This makes us think that the duke might have directly taken part in the genesis of this painting and in that of the London version which also surely comes from the church of San Francesco Grande.

One reconstruction of events, a rather complicated one, has been advanced in relationship to the subject of the Conception (Marani). The dogma of the Immaculate Conception was only sanctioned by the Church in 1854. Yet, it already had its

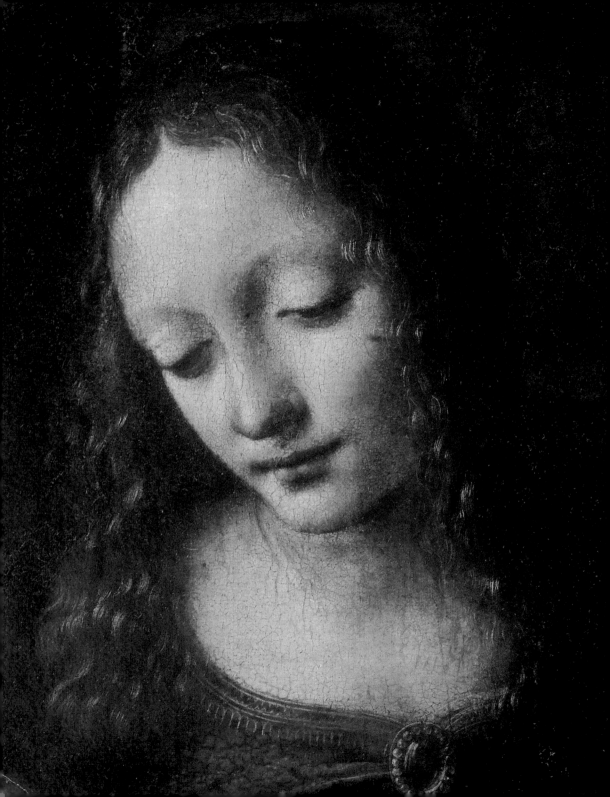

followers in Europe since the fourteenth century. In Milan, Sisto IV, a Franciscan pope, had ignited this theological dispute in 1475 and had allowed its belief in 1477. The interpretation that this assumption gives Leonardo in the *Virgin of the Rocks* could therefore depend on the theological thinking of Amedeo Mendes da Silva. Da Silva was an advisor and personal confessor of Sisto IV as well as the founder of Franciscan convents in Lombardy. The Beato Amedeo had resided for almost fifteen years at the convents of St. Francis in Milan where he was protected by the then duke Francesco Sforza. In the light of this, it does not seem mere conjecture to think that Ludovico il Moro, in the tracks of his predecessor, wished to commission a painting to Leonardo that would reflect Mendes da Silva's theological ideas. This would solve the divergences between what the contract of 1483 ordered and what we see today in the painting in the Louvre, which could have only been brought later to San Francesco Grande to be then removed at an unknown time. The painting that Leonardo prepared for Ludovico il Moro would have therefore only served the function of temporarily filling the place while waiting for the artist to make the version that is in London today and which he would have worked on until 1506–1508.

Leonardo also proved himself as an architect in Milan. His studies to solve the problem of Milan's Cathedral's Tiburio date to 1487–1488. The drawings are preserved in the *Codice Atlantico* and the *Codice Trivulziano*. Manuscript B (Paris, Bibliothèque de l'Institut de France) is dedicated to religious buildings with central plans. Critics have recognized Bramantesqsue ideas in some of these sketches and markedly in those that reproduce central-plan churches with a cross enclosed in a square.

Donato Bramante was, in fact, also called by Ludovico il Moro as a court architect to collaborate with Leonardo on some works for his residence, the Castle of Porta Giovia

(later Sforzesco). Two documents from 1489 and 1490 show Leonardo debtor of the Confraternita di Santa Maria in San Satiro, a building to which Bramante's contribution was decisive. We can however not be sure of Leonardo's direct involvement in the undertaking. His involvement along with Bramante himself in the architectural reconstruction of Santa Maria delle Grazie is more probable. On June 21, 1490 he traveled to Pavia with the Sienese architect Francesco di Giorgio Martini to inspect the construction of the cathedral.

Leonardo's many assignments between 1488 and 1493 included designing the model of the equestrian monument to Francesco Sforza. This commission also came from Ludovico il Moro, who planned to celebrate the dynasty through a propaganda campaign intended to give luster to his image as a sovereign and to legitimize his government (there were more than a few who considered him a usurper because he took the power from the legitimate duke,

his nephew Gian Galeazzo Sforza). Leonardo planned to found the bronze sculpture with an experimental, revolutionary technique: the model was to be in a giant upside down cavity.

The surviving drawings show us that the sculpture was first imagined as a rearing horse that falls a soldier, then it was to portray a trotting horse on a high podium. The project was not completed. In Leonardo's idea the "great horse" would have risen free in the space; a type of sculpture that was only realized a hundred and fifty years later with Gian Lorenzo Bernini. According to the Magliabecchiano, Michelangelo Buonarroti said of the failure of this undertaking to Leonardo: "You made a design of a horse to cast in bronze and you could not cast it and shamefully you let it go." The two artists certainly did not have a good relationship.

Leonardo's anatomical interest for animals and people go back to these years. In this time, he started a book

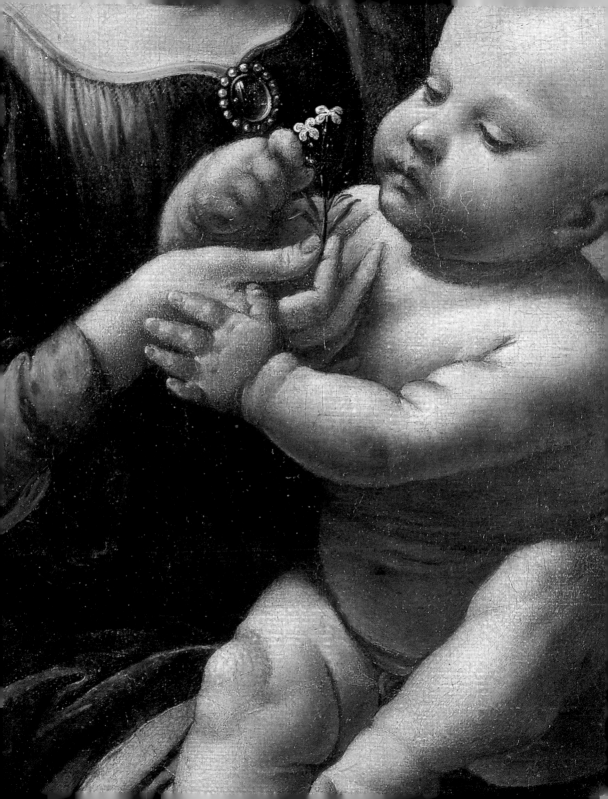

of anatomy dedicated to the human figure, which was an interest that he pursued for the rest of his life. His caricatures can also be traced back to his anatomical studies as variations on the subject of the human face. In the past, this artistic specialty of Leonardo's had great success and was widely reproduced. His physiognomy studies are also connected to the caricatures, in which the artist inverted the proportional relationships of the face, giving expression to precise characteristics and states of mind. An example is a large sheet, in the Royal Library of Windsor Castle, where five grotesque heads are drawn, a clear portrayal of different characters. Around a man wearing an oak leaf garland, who has a classic typology, four faces are grouped that fully express in their expressions the sanguine, choleric, melancholic and phlegmatic types. Vasari tells us how when Leonardo came across strange heads, he observed them for a long time, even for a full day, and he impressed them so perfectly in his memory that he could return home and draw them.

As a ducal engineer Leonardo addressed the problem of regulating water in the city of Milan and in the duke's summer estate, the Sforzesco at Vigevano. The court of the Sforza was a perfect place for the artist to express his multifaceted interests. He provided his services as a feast organizer, for instance. An example was the "Paradise" completed in 1490 in honor of Duchess Isabella d'Aragona, wife of Gian Galeazzo Sforza, for whom he also designed a pavilion in the park of the Sforzesco Castle.

Leonardo often returned to the portrait form in these years. He used it to experiment his "movement of the spirit" theory, his study of optical and perspective phenomenon and the use of color. We have noted the presumed portrait of the musician Franchino Gaffurio, portrayed in a moment that precedes or follows the last note of a song or a piece of music in an atmosphere that seems still, frozen in time. It is the first modern portrait of the Lombardian fifteenth century. Then of course, there are the heights

reached by the portrait of the *Lady with the Ermine* now at the Czartoryski Museum in Krakow, which seems alive in space; the rotation of the woman's body and the movement of the animal give the surroundings circularity. The lady is generally identified as Cecilia Gallerani, the beautiful, cultured and refined favorite of Duke Ludovico il Moro, born in 1473. She even had a child by her lord (born in May of 1491) and received the feudal land of Saronno as a gift from him. The study of shadows that we can see in this portrait, both secondary and primary, goes back to the writings *"ombre e lume"* as attested to by the drawings of *Manuscript C* (in the Biblitèque de l'Institut de France in Paris), which bears the date 1490. These precepts would be best developed in the already mentioned *Treatise on Painting*.

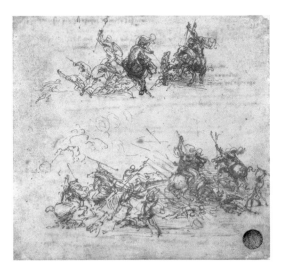

The *Portrait of a Lady* at the Louvre is simple in its construction. It is incorrectly known as *La Belle Ferronnière* and is the last of this pictorial genre that Leonardo painted in his first Milan period. The painting has

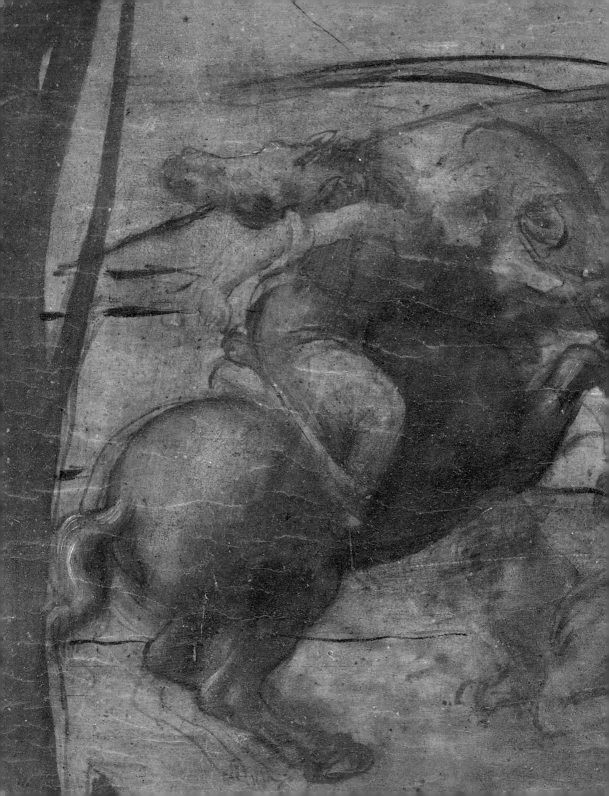

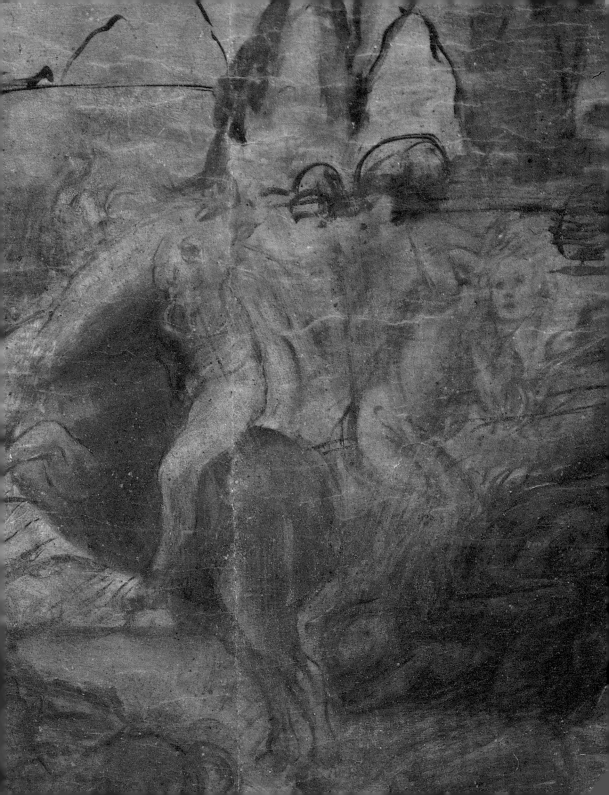

also been attributed to Boltraffio, one of the most gifted of Leonardo's Milanese followers, yet Leonardo's paternity is supported by the magnificence found in the direction of the portrayed woman's gaze, which avoids meeting the observer as if she were requiring him to continuously move to look in her eyes, which gives a three-dimensional aspect to the woman portrayed, almost as if it were a sculpture around which you could walk.

This brings us to the undertaking that could be considered the peak of Milanese pictorial perfection: the *Last Supper* painted on dry plaster in the Dominican refectory of Santa Maria delle Grazie. The master received payment in 1497 and it was mentioned in the *De Divina proportione* by Luca Pacioli in 1498. This makes it easy to assume that Leonardo finished it between these two dates. This can fairly be called the manifesto of sixteenth-century painting; the artist had applied his studies of the "movement of the spirit" on the mechanics, acoustics, perspective, and the diffusion of light and sound. The effect that the *Last Supper* produces at first glance is the breaking up of the walls on which it is painted, as if it were a trompe l'œil device, and the creation of an inexistent space.

The recent restoration established the technique used: one or two layers of tempera paint spread on two preparations, the more interior one adheres to the rough plaster and the layer on which the gesso colors take hold is calcium carbonate based. The experimental technique, though it did cause the loss of color in several parts, allowed Leonardo to work more slowly than he would have had to if he'd used the *buon fresco*, technique giving him the chance to return to it several times to change and adjust it as well as refine the clothes with touches of light and give transparency to the glasses on the table, which he never could have achieved in a fresco.

Matteo Bandello, in one of his novellas (Novella LVIII, 1497) tells us how Leonardo approached the painting of the *Last Supper.*

Codex Madrid: drawing
for casting model for
Trivulzio monument, 1511–1513,
folio 157r, Madrid, Biblioteca
Nacional de España

"He often got up early to stand on the scaffolding. Because the *Last Supper* was high from the ground; he painted from morning to night forgetting to eat or drink, continually painting. He would then remain there two, three or four days without touching the painting, only contemplating it, considering, examining and judging the figures painted. I also saw him, depending on the mood or inspiration of the moment, leave when the sun was high at midday from the Corte Vecchia—where he is working on that marvelous terra-cotta horse—to come to Santa Maria delle Grazie and climb on the scaffolding to give a stroke or two of his brush to the figures and then to leave to go somewhere else."

In the same years, Leonardo worked on several rooms (e.g, "the black room") in the Sforzesco Castle. Today only the Sale delle Asse remains on the ground floor of the large square northern tower. This room was decorated as if it were an arboreal dome such as those that were used in temporary structures

for feasts. The vault was however completely covered over in the early twentieth century and traces of Leonardo's design remain on the wall pieces of monochrome painting with masses of rocks that start from the floor, intertwining roots, small plants, among which we can recognize the *Thippa Litofolio* a lake shrub that Da Vinci loved that appears on a paper showing the study for the *Kneeling Leda* in Rotterdam.

As far as Leonardo's private life during his Milan period, we know from his specific notes that in 1491 the student Gian Giacomo Caprotti da Oreno, nicknamed Salai (devil), was with him, described by Vasari as "a graceful and beautiful youth with fine curly hair, in which Leonardo greatly delighted." Leonardo took care of this boy, feeding and clothing him over the years. The surprising part is the indulgence that Leonardo always showed to this person who was not easy and very badly behaved: "I had two shirts cut out for him, a pair of hose, and a jerkin, and when I put aside some money to pay for

these things, he stole 4 lire the money out of the purse; and I could never make him confess." Leonardo himself noted, and on the side he added "thievish, lying, obstinate, greedy." But this failed to stop him from lending him money, loving him and favoring him among the others and ultimately leaving him the beneficiary of a considerable legacy in his will to compensate him for his "good and loyal services." The nature of these services has differing interpretations. There are those who see the bond between the two as homosexual, partly because of the fact that one of the few documented news of Leonardo in his Florence period is the accusation of sodomy. Beyond that, we can garner the impression from this of a good man, quick to forgive and excuse the mistakes and misdeeds of others.

The year 1499 was a disastrous year for Ludovico il Moro. Leonardo recorded on the cover of one of his manuscript the tragic end of his patron with

the rather dry, impersonal words: "The duke lost his state and his property and his freedom, and none of his works were completed for him." Yet his protector had even given him a vineyard, a property of considerable size (sixteen perches) located before the Vercelliana gate of Milan. In the same year, Leonardo sent six hundred florins as a deposit to the Spedale di Santa Maria Nuova in Florence. This place had a banking function and also kept part of Michelangelo Buonarroti's money.

On July 24, 1499, the news arrived in Milan that Louis XII, king of France, had crossed the Alps and settled his army in the fort of Trezzo, a possession of Il Moro's.

On August 19, the French took Valenza. With Sforza fleeing to Innsbruck, Leonardo also left Milan together with his friend Fra Luca Pacioli and headed to Mantua where the cultured duchess Isabella d'Este had been awaiting him for some time. Just a year earlier, having seen the magnificent portrait *Lady with an Ermine*, she had discussed with

Cecilia Gallerani in an exchange of letters the "comparison" with the portraits by Giovanni Bellini. Of course, the duchess asked Leonardo to paint her portrait. Today we have the beautiful cartoon preserved in the Louvre in Paris, showing the noblewoman in profile. Before returning to Florence, Leonardo spend a short period in Venice in 1500, when the musical instrument maker Lorenzo Gusnasco wrote to the marquise Isabella, praising the qualities of her portrait that Leonardo had shown him. Venice had recently asked him to prepare projects to defend the city from attack from the Turks. He was in Rome in March of 1501 as is evidenced by a paper preserved in the *Codice Atlantico* that on the recto bears the Mausoleum of Hadrian (Castel Sant'Angelo). His presence in Urbe should be considered in light of the relationships he had with Pope Alexander VI Borgia and his son Cesare Borgia, the Duke Valentino whom, Leonardo had likely already met in Milan when they were in the city after the king of France,

Louis XII. He definitely visited Tivoli and the ruins of the Villa Adriana and the degree to which the remnants of Roman antiquity piqued his curiosity is evidenced in his artistic creations after this trip.

The cartoon of *Saint Anne*, now at the National Gallery in London, was planned right after the *Last Supper*, though recently critics have tended to date it later. It reflects the ideas that Leonardo applied to the *Last Supper*; the monumental scale of the figures, the style and even the way of grouping the figures. Carlo Pedretti deftly showed us a transposition of the sculptures of the *Muses* (Madrid, Museo Nacional del Prado) that Alexander VI had found in the Odeon of Tivoli and that Da Vinci would have been able to see during his stay in Rome. The reference to antiquity and comparison with the ancients seems a constant in his works in the early sixteenth century and marks his contribution to the development of the "High Renaissance Style."

Leonardo worked on the subject of *Saint Anne* once he returned to Florence where he and his retinue were the guests of the Serviti della Santissima Annunziata. The monks had commissioned the main altarpiece of their church to Filippino Lippi, but once Leonardo arrived in Florence, according to Vasari, he suggested that he undertake this important assignment. The painting was never made, according to Leonardo's typical ways, and the cartoon was lost. However, this was one of his most admired works; we know about it from thorough descriptions of contemporaries, "He made a cartoon of our Lady with S. Anne and the infant Christ, which not only astonished all artists, but when it was finished, for two days his room was filled with men and women, young and old, going as to a solemn festival to see Lionardo's marvels." (Vasari, *Lives of the Most Eminent Painters, Sculptors and Architects*, 1568).

The artist later returned to the same theme with determination, though the specimen found today in the Louvre in Paris

does not represent the cartoon that was to be used for the painting of the Santissima Annunziata. In Florence, he was sent again to the marquise of Mantua, but Leonardo was busy with the Serviti and completing a small painting portraying the *Madonna of the Spindles* for Florimond Robertet, Louis XII's secretary, of which two versions exist— that of the duke of Buccleuch and that formerly of Battersea, today in a private collection in New York (judged graceful and of fine taste by Wilhelm Suida, but unsigned).

In May of 1502, he admired some vases already in Lorenzo the Magnificent's collection and bearing his initials; these were vases that Isabella d'Este planned to buy.

Due to the disastrous political events of the time, Leonardo entered the service of Cesare Borgia as an architect and general engineer; he obtained a pass that enabled him to move freely in the dominions of Duke Valentino. It was in Urbino where he designed the chapel of Perdono in the Ducal

Palace; he went to Pesaro, Rimini, Cesena, and Cesenatico where he visited the canal port, and finally Piombino where he would return after working at Appiani on the recommendation of Machiavelli in 1505. In Valentino's service, Leonardo hoped there would be use for the war machine inventions for which Milan had not offered great prospects. When the princes of Romagna plotted against the duke and the duke was made prisoner in Imola, Leonardo may have been with him. Bloody events followed, with the massacre of Senigallia, the killing of the plotters and Cesare Borgia's vendetta against Siena and Perugia. The Roman events, the poisoning attempts, and the illness and death of the pope put an end to the terrible, brilliant career of Duke Valentino.

When Leonardo left Florence in 1482, he left a city in which the Medici family, in the person of Lorenzo, dominated both in government and culture. Much had changed when he returned. Lorenzo had died, the Medici family was sent in exile and the republic had been instituted. On November 1, 1502, Pier Soderini was chosen gonfalonier for life, with which a new era began for the city. A decade of new commissions were aimed at creating the image of a great patron, possibly to make more palatable to the Florentine people the difficulties that the republic was suffering because of the war for conquering Pisa and the increasing tax burden that the king of France was demanding. The republic asked Leonardo to make an inspection at the fortifications in Verruca where he went before June 21, 1503, as attested by a letter to Soderini from Pier Francesco Tosinghi, and to study the possibility of diverting the course of the Arno to achieve the surrender of besieged Pisa (a project that was studied at length but finally abandoned as unfeasible). The most important job given to Leonardo in Florence was the commission to decorate a wall of the Sala del Maggior Consiglio (today the Salone dei Cinquecento) in the

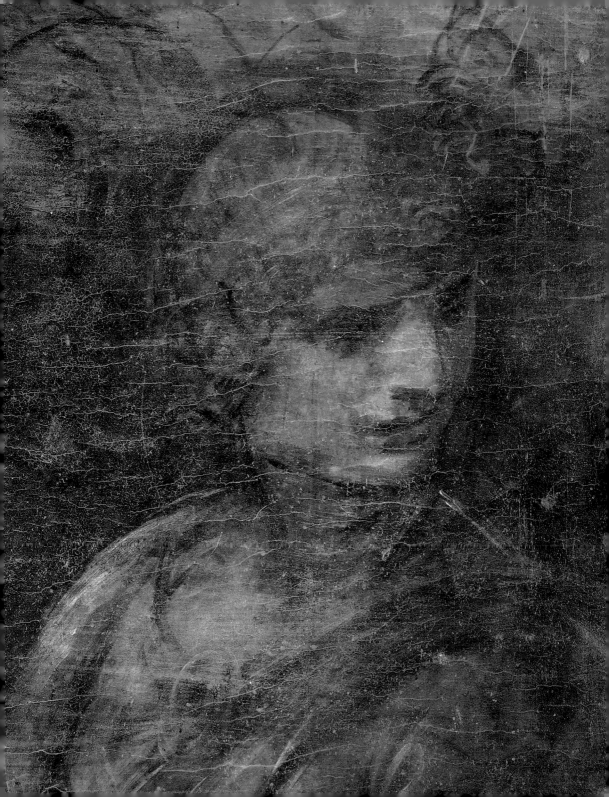

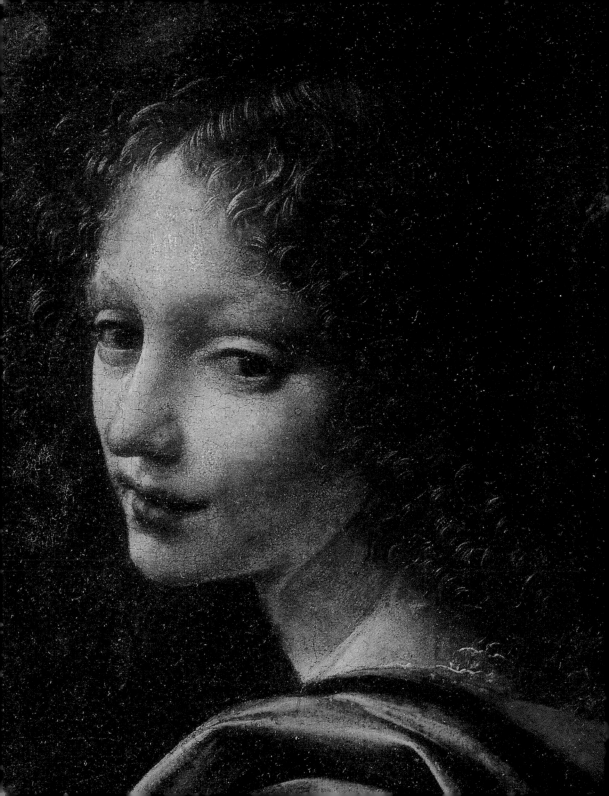

Palazzo Vecchio. It was intended to portray an episode from Florence's war against Pisa, the *Battle of Anghiari*, fought on June 29, 1440 between the troops of the league of papal, Venetian and Florentine soldiers and the Milanese formation of Filippo Maria Visconti led by Niccolò Piccinino. Soderini had concurrently given Michelangelo Buonarroti another portion of the wall in the same hall in which to portray the *Battle of Casciano*, fought on July 29, 1364 and won by the Florentines against the Pisans under the command of the Englishman John Hawkwood. The two great artists, remarkably in Florence in the same years, challenged themselves on the walls of the most representative hall of the Florentine people, the government hall. Da Vinci was given the keys to the Sala del Papa in Santa Maria Novella on October of 1503, and other adjacent rooms in which to prepare the cartoon for the battle. Leonardo must have worked quickly on this cartoon that winter as in January the artist received some wood for his work; in February, paper and canvas for the cartoon itself and an adjustable scaffolding. On May 4, he had the instructions, times and payment methods of the job with a decision by the Signori e Collegi. Yet, by December 1505, he interrupted the transfer of the cartoon on the wall of the hall because the paints on the wall melted due to the technique used, a clumsy attempt at encaustic. According to Vasari's story, Leonardo had achieved terrible results in experimenting with this technique because of misunderstanding a recipe by Plinius. However, Da Vinci's attempts should not be dismissed as mere whims as they were aimed at a very specific goal, to give the wall painting a mysterious depth, transparency and luminosity of oil painting rather than the uniform lightness and traditional coloring of the fresco—oil painting had taken on these characteristics thanks to Leonardo himself. The cartoon was scattered immediately after his departure. Likely the largest part of it, along with other things in his property, stayed at the hospital of Santa Maria Nuova while

the piece portraying the battle around the banner, used as a starting base for the wall painting, remained in Palazzo Vecchio. According to Benvenuto Cellini, the cartoon was brought to the Sala del Papa in Santa Maria Novella: "And for the entire time that they were there [he also referred to Michelangelo's cartoon in Palazzo Medici] intact, they were the school of the world." A certain fact is that in 1512, the Sala del Maggior Consiglio was turned into a barracks and Leonardo's painting was protected in a scaffolding. As we know, nothing survived, neither the painting by Leonardo, who had established himself in Milan in service of the French, nor the cartoon by Michelangelo (he had never started to transfer it to the wall), who established himself in Rome with Pope Julius II. A pale reflection of what must have been Leonardo's creation can be seen by examining the nonetheless beautiful version made by Rubens, held in the Louvre, portraying only the battle episode. The few surviving drawings consist of two heads in pencil for the central figures of the battle and the head of a soldier in profile and another two or three sheets with clashes of horsemen. They can, however, never restore the vision of the whole to us.

When Leonardo was older, probably between 1501 and 1506, he dedicated himself to preparing the *Leda*, though thoughts around this subject can already be seen in the 1490s. From the love between Leda and Jove, who turned himself into a swan for the occasion, Castor, Pollux, Helen and Clytemnestra were born. There were two solutions Leonardo proposed for giving life to the mythological story: the *Standing Leda* and the *Kneeling Leda*. For the former, the Leonardian conception can be recognized in the painting in the Galleria Borghese in Rome, although the most recent criticism tends to consider it and the piece formerly in Spiridon and now in the Uffizi, as a derivation of the master. The *Kneeling Leda* version is known

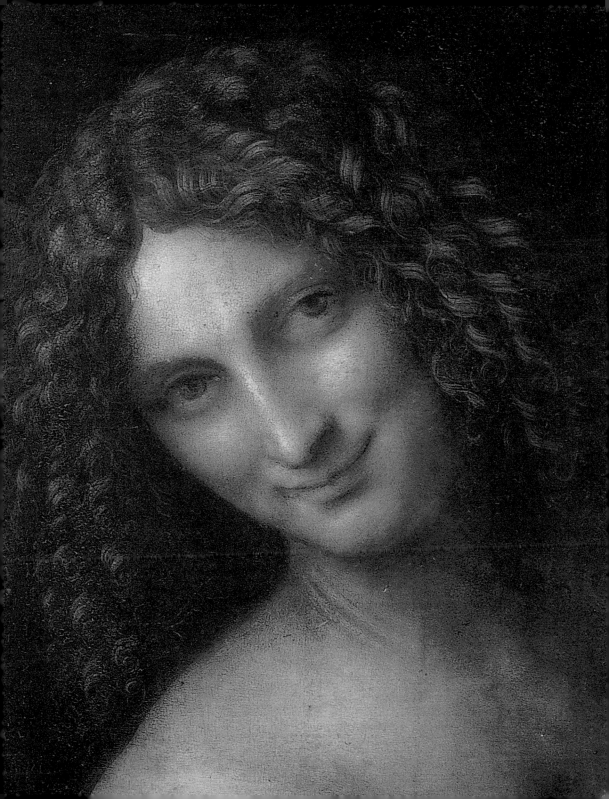

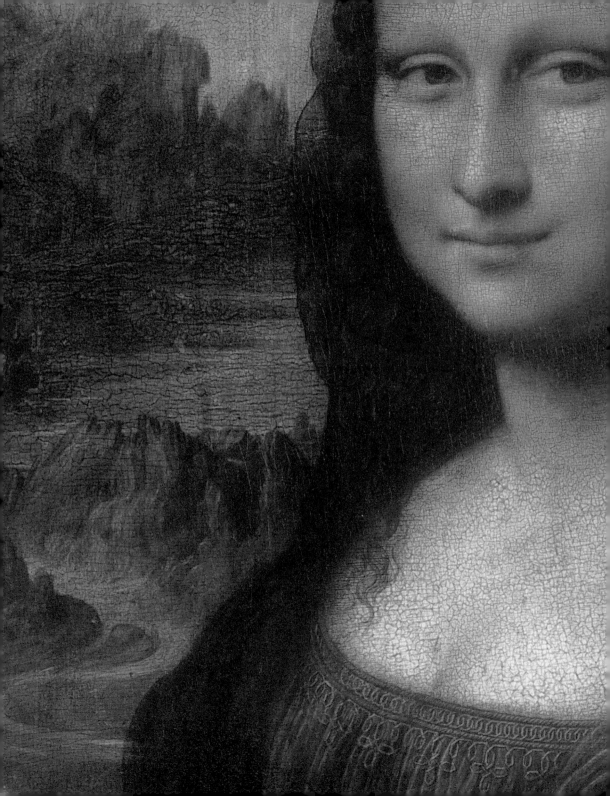

through two drawings, one now in Rotterdam (Boijmans Van Beuningen Museum) and the other in Chatsworth (Collection of the Duke of Devonshire). Again what is important to know is the ascendancy of this model of antiquity (the *Kneeling Leda* is taken from an antiquity sculpture of a crouched Venus) and its great popularity in the sixteenth century. Even Raphael drew a Leda (*Drawing of Leda*, Royal Library in Windsor Castle) inspired by Leonardo's creations.

Leonardo's interest in antiquity was also reflected in his work that in the public imagination is the definition of portrait: *Mona Lisa*, i.e., *The Portrait of Mona Lisa del Giocondo*. The work was definitely started in Florence circa 1503–1504, though it may have only been completely about 1510–1515.

Through Vasari's words, we fully understand the character of this work: "In his head, whoever wished to see how closely art could imitate nature, was able to comprehend it with ease, for in it were counterfeited all the details that with subtlety are able to be painted. Seeing that the eyes had that luster and watery sheen that is true to life, and around them were all those rosy and pearly tints, as well as the lashes, which cannot be represented without the greatest subtlety. The eyebrows, through his having shown the manner in which the hairs spring from the flesh, here more close and here more scanty, and curve according to the pores of the skin, could not be more natural. The nose, with its beautiful nostrils, rosy and tender, appeared to be alive. The mouth, with its opening, and with its ends united by the red of the lips to the flesh-tints of the face, seemed in truth, to be not colors but flesh. In the pit of the throat, if one gazed upon it intently, could be seen the beating of the pulse. And, indeed, it may be said that it was painted in such a manner as to make every valiant craftsman, be he who he may, tremble and lose heart." (Vasari, *Lives of the Most Eminent Painters, Sculptors and Architects*, 1568).

The lack of human presence in the primordial landscape behind the woman makes the portrait enigmatic and timeless. This work met with enormous success among its contemporaries and especially in the nineteenth century when it became the most famous painting in the world. A French expression says, "As famous as Mona Lisa." Its success and reinterpretation, very often by way of debunking commonplaces (almost a kind of "La Giocandoclasm") are seen in works by twentieth-century artists such as Duchamp and Dalí.

Its theft on August 21, 1911 sealed the painting's fame. The writer Guilliaume Apollinaire and the artist Pablo Picasso got in trouble, but rightful blame went to Vincenzo Peruggia, an Italian who was the museum's decorator. The thief was caught and sentenced to a year and fifteen days of prison, and the painting, which reappeared in Florence in an antique shop, was returned to the Louvre on January 4, 1914.

On May 30, 1506 Leonardo asked the Signoria for a permit for three months to go to Milan. In August of the same year, Charles d'Amboise, French marshal and governor with the duchy of Milan and Giaffredo Caroli, vice chancellor, asked the artist to stay in Milan for another month. The gonfalonier Pier Soderini reminded the governor that Leonardo had started a large work in Florence. However he could not exert the pressure that he might have liked because Florence was connected to France with a long-standing bond and was heavily indebted to it. The following year the king of France personally asked if Leonardo could stay in Milan in his service and so he did (aside from a short stay in Florence). His commission to erect another equestrian monument dates to this stay; this one to Gian Giacomo Trivulzio, marshal of the king of France. That project, however, also failed.

On March 22, 1508, Leonardo was a guest of Piero di Braccio Martelli in Florence, where according to Vasari, he helped his friend Giovan Francesco Rustici to model the

three statues cast for the Baptistery in Florence; the Baptist between the Levite and the Pharisee. The work was accomplished with consulting from the master, but without his direct involvement. Leonardo shared friendship with the younger Rustici, who practiced art more for prestige than for money. Having shown Da Vinci his respect, he earned the unconditional support of the master in many realms, including painting horses. Aside from this time in Florence, Leonardo stayed in Milan where he served as a painter and official engineer to the king of France, dedicating himself to the study of urban planning solutions for Milan, hydrographic and geological problems and the study anatomy.

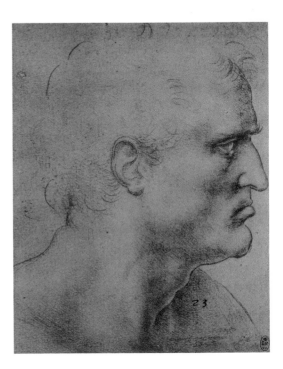

He left Milan for Rome on September 24, 1513 with his favorite pupils: Giovan Francesco Melzi, the oft-mentioned Salaì, a certain Lorenzo and the Fanfoja. In Urbe he had a studio built for himself in the Belvedere by Giuliano de' Medici, who was his protector and to whom Leonardo served as a military consultant.

Here he dedicated himself to scientific studies and plans for draining the Pontine swamps; he came into contact with the new Medici pope Leo X, son of Lorenzo the Magnificent.

He made a trip to Bologna following Giuliano de' Medici and Leo X who went there to meet the new king of France, François I. When his protector Giuliano de' Medici died in March of 1516, Leonardo accepted François I's invitation to go to France to the castle of Clous near Amboise, where he resided until his death, fulfilling the role of *premier peintre et ingénieur et architecte du Roy, Meschanischien d'Estat*. In France, he was much loved and appreciated. His salary was commensurate with his fame; for just a period of two years he received a pension of 10,000 scudi, a considerable sum.

In October of 1517, he received a visit from the secretary of Cardinal d'Aragon, Antonio de Beatis, who saw three paintings in his study: Mona Lisa, a "young Saint John the Baptist" and a "Madonna placed in the lap of Saint Anne," and all of his anatomy drawings.

Leonardo recorded that he was still in Amboise in the Castle of Clous in the *Codice Atlantico*, foglio 249 recto for the last time on June 24, 1518. He died on May 2, 1519. He left in his will, dated April 23, 1519, all of his manuscripts, drawings and instruments to his student Francesco Melzi; while the paintings in his studio went to his student Salaì who brought them all to Milan, as they appear in the inventory of goods prepared the year after his death in Milan on January 19, 1524. The scattering of Leonardo's legacy began on this date.

He did not forget his blood brothers in his will (born from his father's third and fourth marriages), to whom he left a farm in Fiesole and a deposit of four hundred scudi. Once again, he proved himself a magnanimous person who did not bear grudges against his family members, who upon the death of his father Ser Piero on July 9, 1504, had kept him out of the inheritance. The announce-

ment of the master's death was made to his family members by Francesco Melzi.

The question of Leonardo's workshop and school remains open; if it really existed and, if so, if by Leonardo's express desire. Giovanni Antonio Boltraffio, Marco d'Oggiono and Salaì were definitely students starting in 1490; Giampietrino shortly after that and Francesco Melzi later. They were all in the master's workshop, though it is not clear if they came to Leonardo's studio after they had already learned the rudiments of art or if they had been apprenticed with the master since they were children. Boltraffio and d'Oggiono definitely worked on some of the master's works, but they also took independent commissions. The other Lombardian students were: Slario, Ambrogio de' Predis, Luini and Bartolomeo Veneto. The first news that Leonardo spent some of his time teaching his pupils comes from a letter to the secretary of cardinal Louis d'Aragon, Antonio de Beatis, mentioned earlier: "And though this Lunardo cannot paint with the ease of the past, he still can make drawings and teach others." In his Florentine period, Leonardo already worked on paintings that his students painted; this was found in a letter from April 3, 1501 in which Fra Pietro da Novellara, writing to Isabella d'Este, after having described the cartoon for Saint Anne tells us that, "He did nothing else, except some boys make portraits and he sometimes puts his hand to them."

As such, there is no doubt that Leonardo kept a kind of workshop. This makes us consider with less circumspection the information from seventeenth-century sources that tells of the existence of a Leonardesque academy, based on the existence of Da Vinci engravings that bear the words "Achademia Leonardi Vinci."

In five hundred years, Leonardo's critical success has not been eclipsed. Leonardo the scientist however is a twentieth century discovery. Considering this, it is a little surprising that for the previous three

hundred years, his fame was derived exclusively from paintings, which, as we have noted during this essay, were often lost or left unfinished. This enthusiasm led to attributing to him works that were created by his Florentine or Lombardian contemporaries. There is ample literary tradition dedicated to Leonardo in which many illustrious names appear. It is, as such, impossible to outline his critical fortunes even in a summary form. The list would include scholars, critics, poets and writers from every century; and even a psychoanalysis, possibly the most famous of all, by Sigmund Freud, in his *Leonardo da Vinci: A Study in Psychosexuality*, published in 1947.

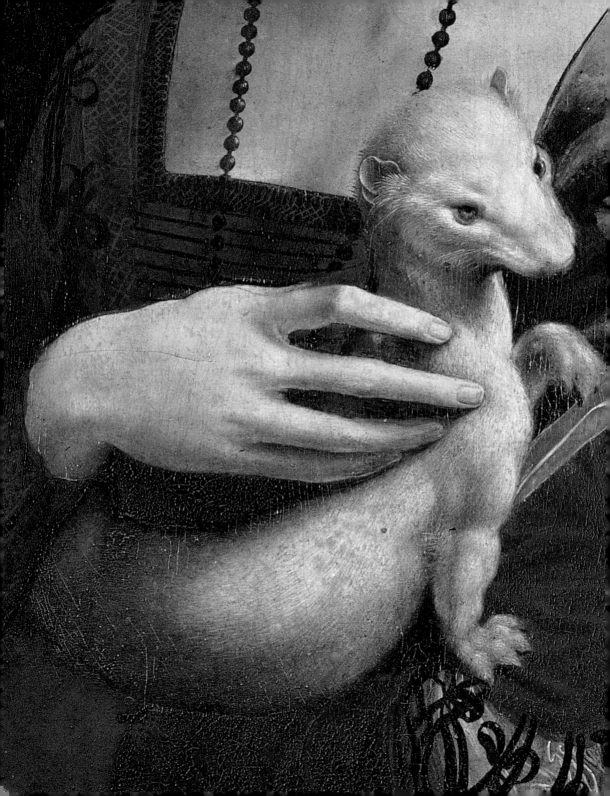

The Masterpieces

Madonna of the Pomegranate (Dreyfus Madonna)

c. 1469
Oil on panel, 15.7 × 12.8 cm
Washington, D.C., National
Gallery of Art, Kress
Collection

This work, which became part of the Kress Collection in 1951, has had a controversial history. Attributions has been given to Andrea del Verrocchio, his workshop and Lorenzo di Credi. Contemporary criticism accepts it as Leonardo's first work. The small painting indeed shows the hand of a student of Andrea's who is still immature yet graced with great talent, as we might imagine Leonardo before he was twenty. To be convinced, one need only compare it with a painting in the monastery of Camadoli, which is similar in its organization and also comes from Verrocchio's workshop, but from a totally different and less experienced hand. In Dresden, a drawing in silver point attributed to Lorenzo di Credi, is, with good reason, considered an influence on this painting. However, this should not lead us to believe that the *Madonna of the Pomegranate* can be attributed to Credi. Rather, it reinforces the idea that it was a common practice in a workshop to use the same studies to paint paintings, which became testing grounds for a student's talents.

The two figures, while showing a great gentleness and intent love, still do not appear to be much in relationship to one another. The Virgin seems to be looking at the pomegranate and the Christ child offers her a part of the fruit she just plucked. The color agreement is harmonious, a shade of red that goes well with a dusty blue. The Virgin's face emerges from a dark background, probably a wall between two rectangular windows that open on a view of a landscape which is still but a foretaste of that typical of Leonardo.

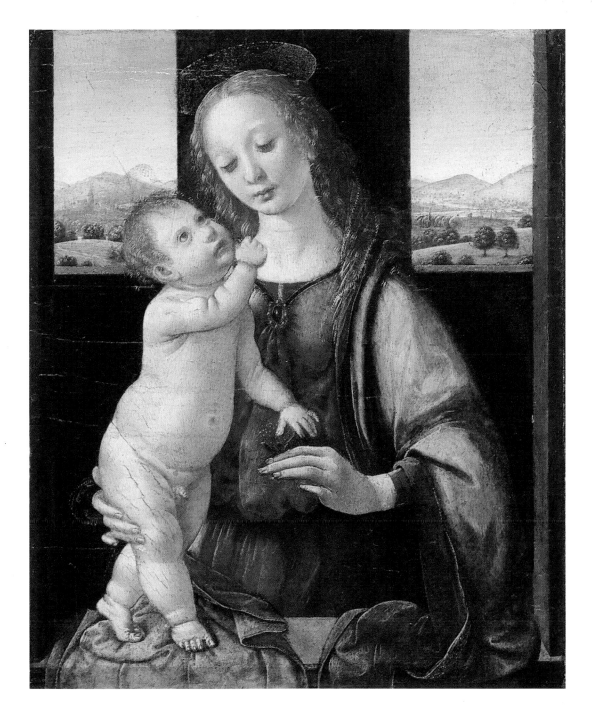

Madonna and Child
(Madonna of the Carnation)

c. 1470
Oil on panel, 62 × 47.5 cm
Munich, Alte Pinakothek

We had no news of this painting before it came into the collection of Dr. Albert Haug of Günzburg where it was attributed to Dürer. In 1886, it moved from here to the museum. It was immediately identified by the curator of the museum at the time, Adolph Bayersdorfer, with the _Madonna della Caraffa_, which according to Vasari was in the collection of the Florentine pope Clement VII, nephew of Lorenzo the Magnificent: "Leonardo next did a very excellent Madonna, which afterwards belonged to Pope Clement VII. Among other things it contained a bowl of water with some marvelous flowers, the dew upon them seeming actually to be there, so that they looked more real than reality itself" (_Lives of the Most Eminent Painters, Sculptors and Architects_, 1568). That there are quite a few existing copies of the painting demonstrates its importance and success in Tuscany and Flanders. It already shows the features of Leonardo's pictorial universe: the coiffure of the Virgin is reminiscent of studies for the head of _Leda_ (a work done almost thirty years later); the mountains are densely atmospheric, to reappear in _Mona Lisa_ and the first version of the _Virgin of the Rocks_. The small painting has an interesting _craquelure_ (pattern of cracks) on almost the entire painted surface, especially concentrated on the face. The effect is caused by the large amount of oil paint (that congealed too quickly), which Leonardo used to give the image a vividness worthy of nature and of Flemish painters, who he clearly sought to emulate. The work has close ties with the _Dreyfus Madonna_ , but the space around the architectural interior is well-orchestrated and the elegant double lancet window looks out on a landscape whose mountains are arranged in two levels of depth, distance scaled through the skillful use of color and "aerial perspective."

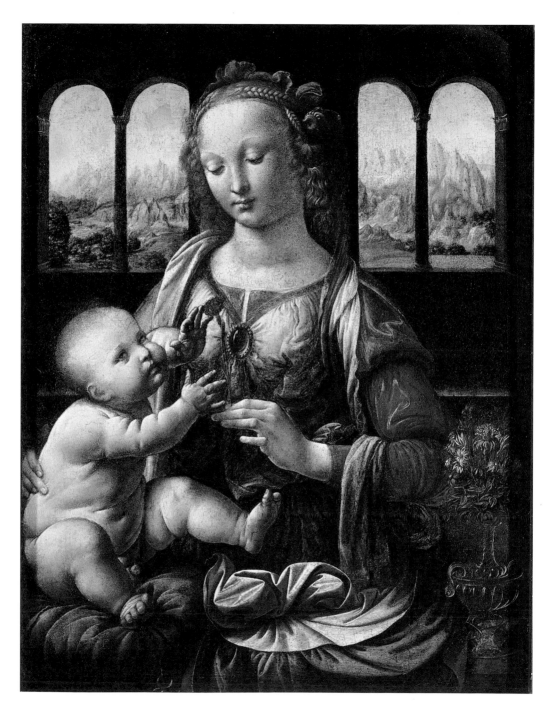

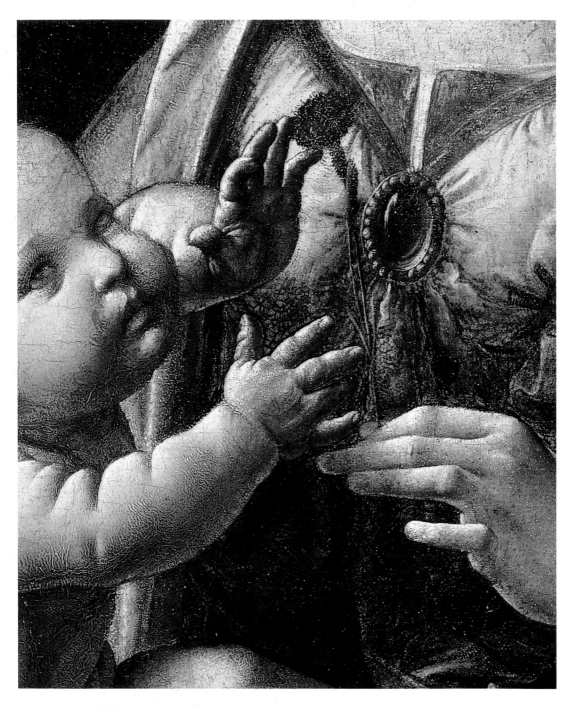

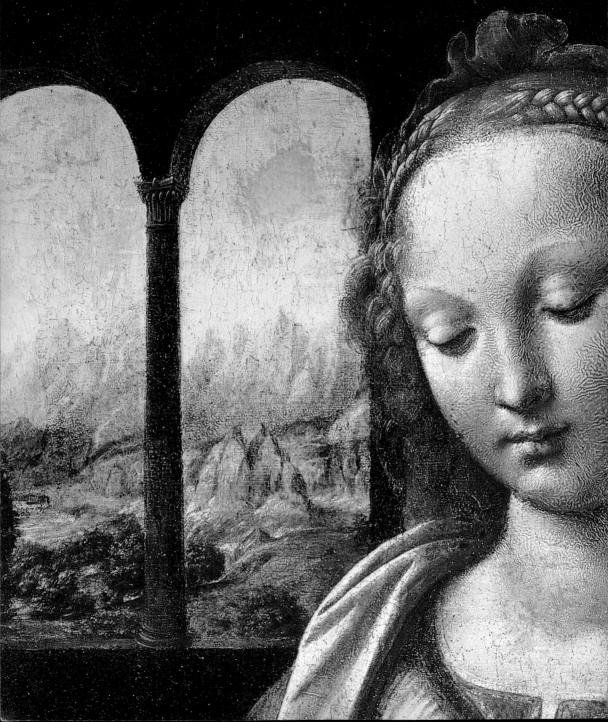

The Annunciation

c. 1472–1475
Oil and tempera on panel
98 × 217 cm
Florence, Galleria degli Uffizi

The painting had been traditionally attributed to Domenico Ghirlandaio. In 1867, it was taken down from the wall of the sacristy of the church of Saint Bartholomew, annexed to the suppressed Benedictine monastery, and moved to the Uffizi.

At first glance the perspective arrangement and the anatomic representation in the work appear to be flawed. The many _pentimenti_ (second thoughts) would suggest that the artist had some difficulty in organizing the scenic space. The angel Gabriel has just landed from flight with his wings still open and is placed asymmetrically to Mary who seems to be held by the entry of the noble building with strongly Florentine architecture. She appears to have three legs because of the edge of her mantle resting on the seat arm. She has a beautiful but inexpressive face. Her right hand cannot easily reach the left margin of the book because the lectern on which it rests is too far from her grasp. Yet, if you look more closely, you can see that the composition is geometrically arranged (observe the lines that mark the floor) and, if you observe the painting from a specific point of view, from the right and a little below, you realize that these perspective errors are magically corrected by the gaze (Natali, 2002). What at first sight seem to be incongruities become composi-

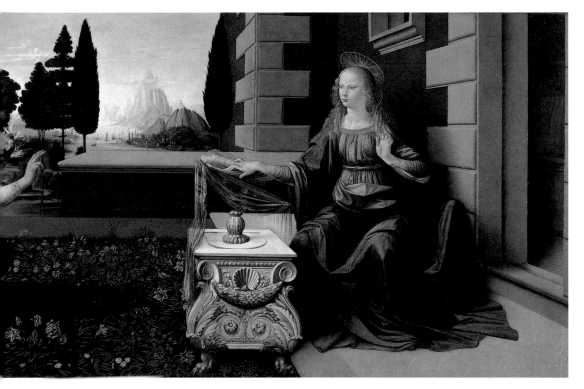

tional expedients, anamorphic experiments which Carlo Pedretti, a leading Leonardo scholar, has shown to be practiced in various periods of his artistic history (Pedretti, 1957). While admitting that there are incongruities, they do not invalidate the painting because its as comes from the "atmospheric" landscape, the light and the color. The view that we can admire from the balustrade is a magical lake environment, with hillocks and steep mountains and a strongly backlit procession of trees of diverse varieties and the absolute absence of human presence.

Ginevra de' Benci

c. 1474–1476
Tempera and oil on panel
38.8 × 36.7 cm
Washington, D.C., National
Gallery of Art
On the back of the painting,
a cartouche with the motto
VIRTUTEM FORMA DECORAT

In the nineteenth century, this small painting was located in the Viennese palace of the princes of Liechtenstein and was bought by the American museum only in 1967. It is highly likely that it was cut off at the bottom by a third party, suffering removal of the lower part of the bust with the hands possibly only sketched. The woman is portrayed in her full diaphanous pallor, worthy of a Flemish painter, with those touches of light on her face, against of a juniper tree (which, in Italian, *ginepro*, is consonant with her name, Ginevra), which is strongly backlit. The artist used his finger to better spread the color and make the skin seem alive, leaving his fingerprints on the painting. The motto *Virtutem forma decorat* (beauty adorns virtue)is written on the cartouche that ties the garland, which stands on a background of porphyry and is formed of three plants, juniper, laurel and palm. This is all painted on the back of this painting, and it is clearly meant to relate to the woman portrayed. Ginevra was born in 1457, the child of Amerigo di Giovanni Benci and the seven-year-old wife of Luigi di Bernardo di Lapo Niccolini. This portrait may have been painted for their wedding on January 15, 1474 (although, the woman does appear be older than seventeen). A more recent theory suggests that the work was painted at the request of Bernardo Bembo, Ambassador of Venice in Florence in 1475 and in 1478/1480, who was so attached to Ginevra that he commissioned Cristoforo Landino and Alessandro Braccesi to write verses celebrating his feelings. As such, the plants and the porphyry painted on the back could allude to the chastity and endurance of this love. Leonardo's relations with the Benci family were intense and long-lasting. *Saint John the Baptist* in the Louvre is also said to be have been painted for this family. Giovanni Benci and the *Adoration of the Magi* in the Uffizi were left incomplete in Amerigo Benci's house upon Leonardo's departure for Milan.

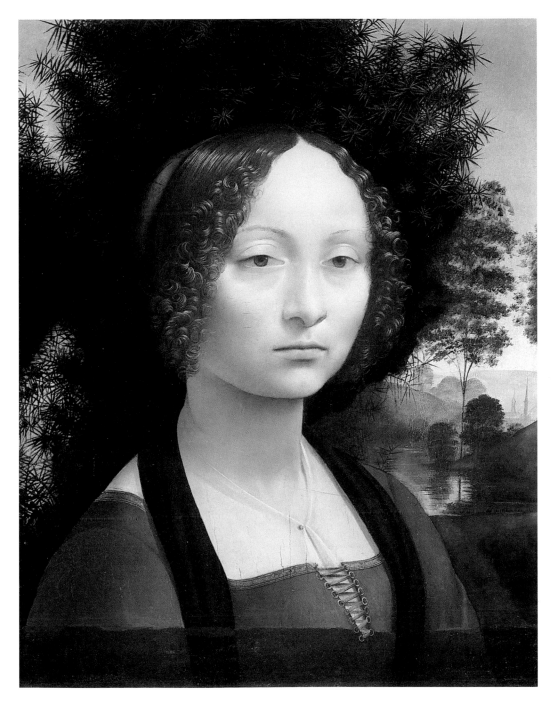

Baptism of Christ by Verrocchio
(detail of angel and landscape)

c. 1475–1478
Oil and tempera on panel
177 × 151 cm
Florence, Galleria degli Uffizi

Sources mention this work from the church of San Salvi in Florence as belonging to the Vallombrosan order and probably painted on their commission. At an unknown date, the painting was moved to the convent of Santa Verdiana, belonging to the same order, and was then transferred during the Napoleonic wars to the Accademia di Belle Arti in 1810 and the Uffizi in 1914.

Vasari was the first to mention Leonardo's involvement on this painting. It has been suggested that all of the parts painted in oil are Leonardo's: the face of the angel in profile (created after having scratched away the older base preparation), some curls on the other angel, the landscape in the background and Christ's face, in which we can see the use of the thumb to create the color transitions on the skin. The Baptist's body is linked to the Pollaiolo environment, while the hands of God the Father and the palm tree seem so archaic and of low quality to cause no problems of attribution between Verrocchio and Botticelli.

Recent scientific analysis (taken by infrared) have revealed that the view of the landscape underneath the one that is visible to the bare eye has a vast variety of tree-types very common in late fifteenth-century Florence and idealized hilly contours. In the original, only Christ's feet were immersed in a stream of water. Now the water has taken over and covers almost all of the work's foreground.

"We are immediately led to believe that the affinity between the nature portrayed in the *Annunciation* and that which survives invisible to the bare eye in the *Baptism* may be the evidence of a temporal adjacency as well as a conception that came about in the some artistic environment" (Natali, 2002).

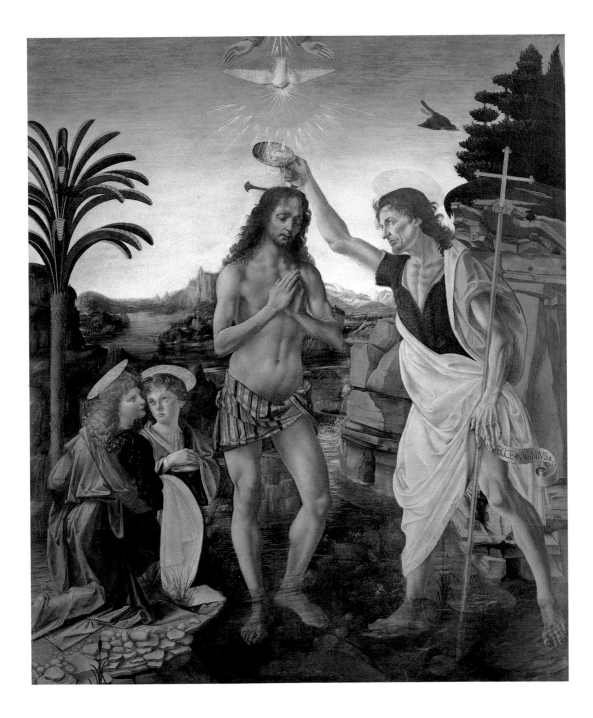

94

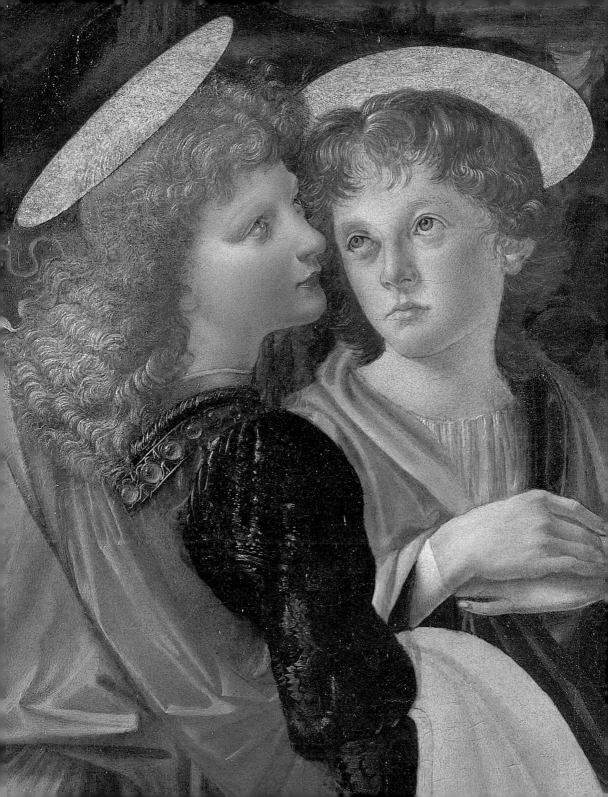

Madonna and Child
(Benois Madonna)

c. 1478–1482
Oil on panel transferred
to canvas, 48 × 31 cm
St. Petersburg, The State
Hermitage Museum

This painting is possibly to be identified with one of the two Madonnas began by Leonardo in 1478 and completed in the years before he moved to Milan in 1482. A page kept in the Uffizi bears the memory of these two Virgin Marys, which contains the signed annotation. The small painting was bought in 1824 by the merchant Sapozhnikov in Astrakhan and later came into the possession of the Benois family, who gave it the name by which it is universally known. It came to the Hermitage only in 1914.

This is a transition work that marks the divide between Florentine Leonardo who was firmly tied to Verrocchio's teachings and Leonardo's work in Lombardy. The composition shows that he had surpassed the systems that he had learned as a youth in the workshop in Florence. The two figures of the Mother and child, constructed on oblique and counterpoised spatial lines, are skillfully connected to one another with the small flower that serves as a device to connect their gestures. The gentle movements and the hands and the gazes from the two protagonists render the scene intimate and homey. The use of color with modulated tones and the warm light create a rounding of the forms, a shaded and soft contour of the figures, which imbues them with life and motion in the atmospheric space that contains them. The Virgin's lively and compelling expression and the contour of her face as an upside triangle are completely new, a prelude to the face of the angel of the *Virgin of the Rocks* in the Louvre in which this type was further refined and perfected.

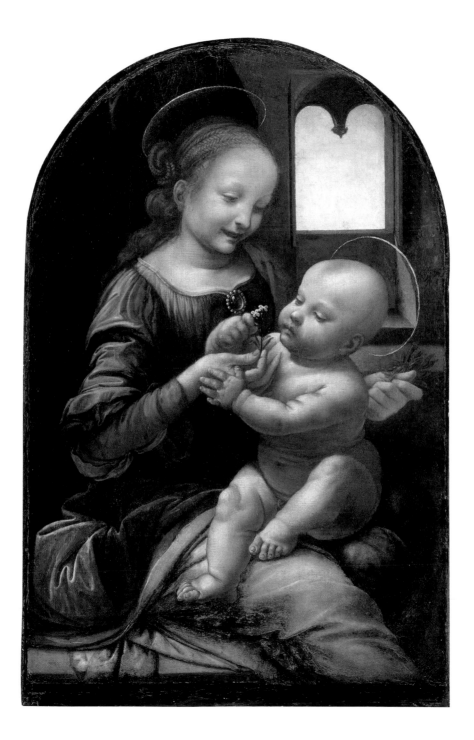

Saint Jerome

c. 1480
Tempera and oil on panel
103 × 75 cm
Vatican City, Pinacoteca
Vaticana

This is one of Leonardo's works mentioned in the inventory of goods inherited by his student Gian Giacomo Caprotti, better known as Salaì, and it was one of the works brought to Milan in 1525. It then belonged to Angelica Kaufmann in Rome and then went into Cardinal Fesch's collection to ultimately be purchased between 1846 and 1857 by Pope Pius IX.

The artist probably started this painting around 1480. It is related in style to the *Adoration* in the Uffizi. It remained unfinished because of the painter's departure for Milan. Leonardo appears to have mentioned it himself in a list of works and objects (*cierti San Gerolami*) drawn up for the trip. "An unfinished work reveals the manner of preparing the picture, moving from the last to first levels, which were, precisely, intended to be left for last as if to provide the illusion, partly 'stratigraphically' of volumes extending behind the surface of the painting's frontal surface" (Marani 1994). The twisting of the body and the languid expression of the face with the bony and tilted head corresponds closely to Greek sculpture. The arrangement of the figure suggests Leonardo's anatomical interests, which were directed in these years at the dynamic nature of the human body in space. The saint in this pose produces such a strong sixteenth-century effect as to fully justify Vasari's definition of Leonardo as a harbinger of the "modern style." The repentant saint is in the act of beating his chest, kneeling as shown by the knee's bending; the sculptural organization of his body is reconciled with great fluency to the drawing/pictorial procedure. The rocks to the right are a prelude of the upcoming *Virgin of the Rocks* in the Louvre. On the left, the opening of a landscape defined by a few sharp peaks is barely perceptible on the greenish preparation of the painting.

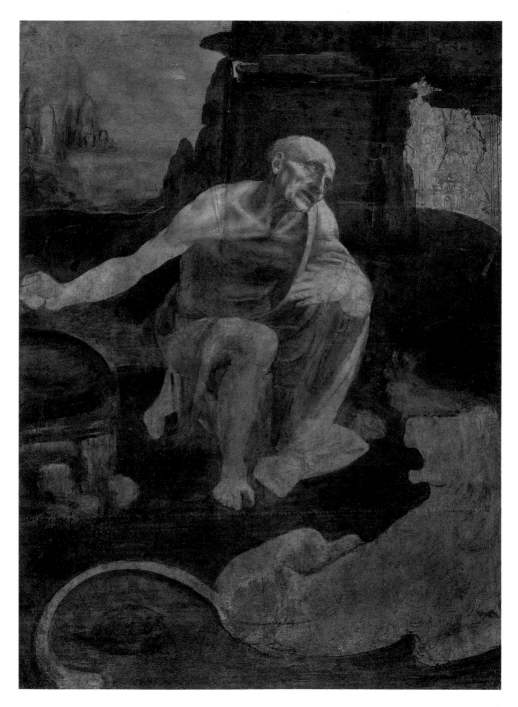

Adoration of the Magi

1481–1482
Oil on panel, 246 × 243 cm
Florence, Galleria degli Uffizi

The large painting was commissioned in March of 1481 by the monks of San Donato a Scopeta—regular parishioners of Sant'Agostino of the congregation of San Salvatore. As it was left unfinished, it remained in the rooms of his friend Amerigo Benci's house when Leonardo left for Milan. It then went into Antonio and Giulio de' Medici's collection and entered the Uffizi in 1794 (after other exchanges including the Villa di Castello near Florence.)

The scene depicted is dynamically organized. The actual Adoration of the Magi takes place in the foreground, where a sense of circularity dominates, a whirlwind of actions and gestures pivot around the grouping of the Virgin and child. The background seems to tell the story of a history preceding the Epiphany. On the right, there is an armed battle and unsaddled and rearing horses. On the left, men are busy on the stairway, intent on rebuilding the ruined architecture with new parts that coexist with broken structures. On the broken arch there are small shrubs as we sometimes see on constructions in which the work was interrupted for some reason and nature had took over. Reflectographs and infrared rays were employed in planning for a restoration which, though it has not yet been carried out, is needed because of the many impurities that compromise its complete legibility. These studies clearly reveal "the presence of carpenters and masons, briskly working on the steps and the wall above the arches between the stairways; men who pull on baskets and wooden boards, men portrayed in the act of shoveling or placing bricks" (Natali, 2002). Unfortunately, none of these details can be seen with the naked eye. In fact, looking at the painting, we have the impression that that reddish brown surface levels and flattens everything.

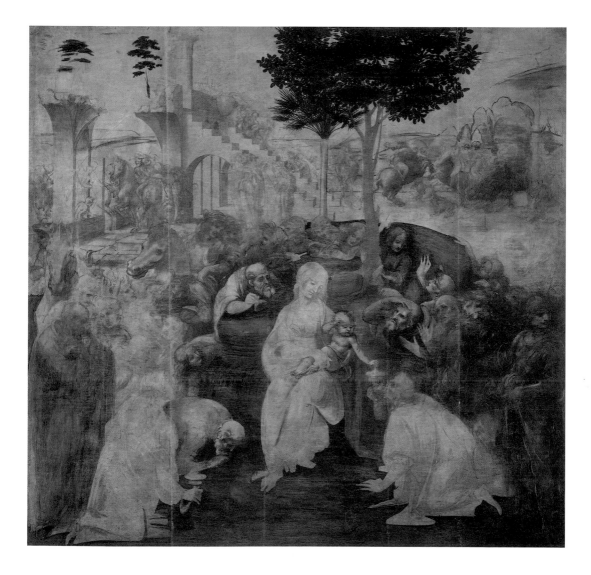

The Virgin with the Infant Saint John Adoring the Infant Christ Accompanied by an Angel (Virgin of the Rocks)

1483–1486
Oil on panel, 199 × 122 cm
Paris, Musée du Louvre

Although there are those who maintain that this painting was made in Florence, it has to be identified with the painting commissioned to Leonardo by the members of the Compagnia della Concezione, who had their altar in San Francesco Grande in Milan. The chapel had been founded in the fourteenth century by Beatrice d'Este, wife of Galeazzo I Visconti, and was destroyed in 1576. A seventeenth-century mention of the painting was made by Cassiano dal Pozzo, who said he had seen it in Fontainebleau in 1625. According to the most credited tradition, the painting was probably sent by Ludovico il Moro (who definitely played a fundamental role in the painting's origins and therefore had ownership rights over it) as a wedding gift to Maximilian of Hapsburg, who married Bianca Maria Sforza. From Innsbruck, it would have gone to France when Eleonora, Massimiliano's granddaughter, became the wife of François I.

The commission contract, dated April 25, clearly specified that the work to be painted was a large altarpiece. The central painting was assigned to Leonardo, the side paintings to Ambrogio de' Predis (associated with two panels portraying musician angels now in the National Gallery of London), and the coloring and the gilding of the altarpiece to Ambrogio's brother, Evangelista. All was held in a magnificent frame that had already been sculpted and carved between 1480 and 1482 by Giacomo del Maino.

The scene takes place in a rocky landscape that is architectonically orchestrated in which flowers and water plants (showing great botanical precision) dominate. A stream of water can be glimpsed in the distance. The angel looks towards the observer with a slight smile and points to Infant Saint John. This evocative detail is absent in the version in London. The great success of this composition is evidenced by the many copies in existence by Italian and foreign artists.

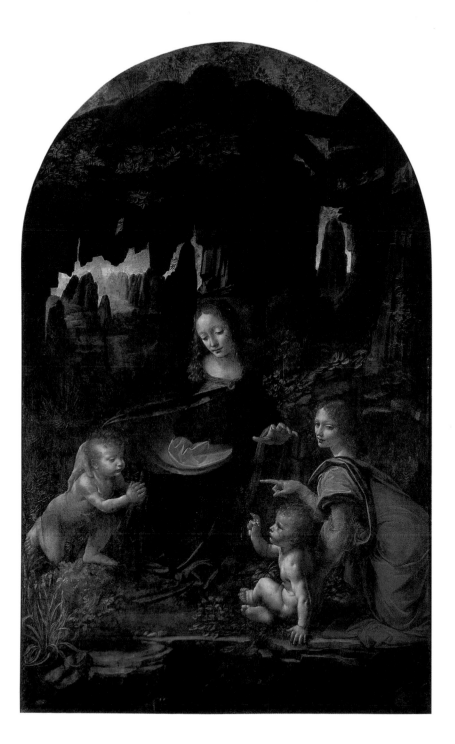

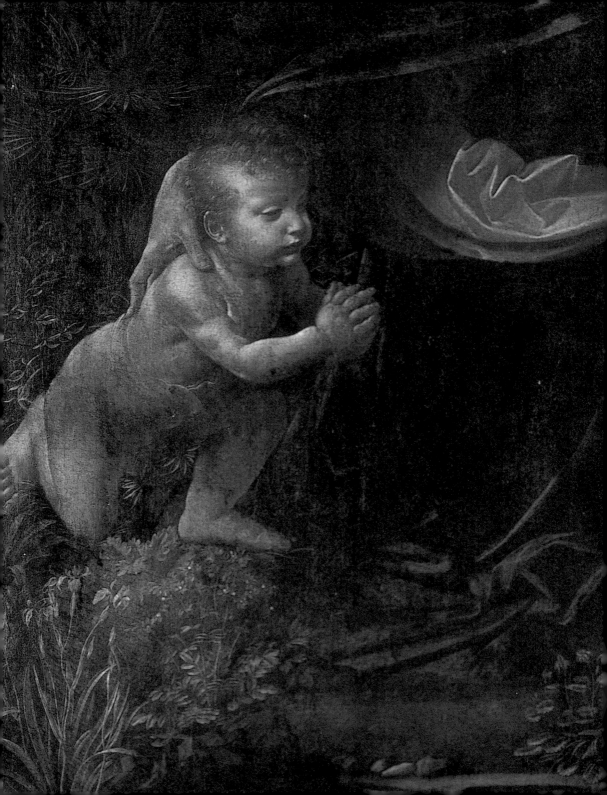

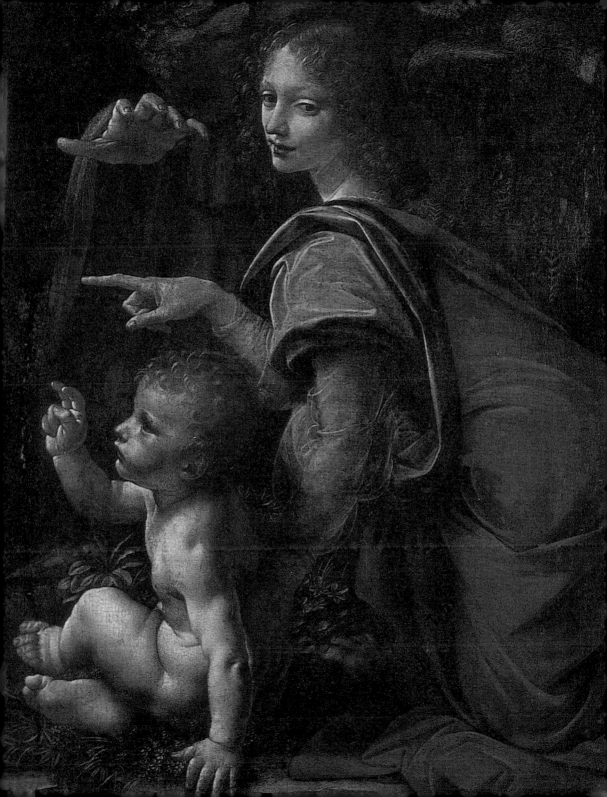

Portrait of a Musician
(Franchino Gaffurio?)

c. 1485
Oil on panel, 43 × 31 cm
Milan, Pinacoteca Ambrosiana

The portrait was first mentioned in the Ambrosiana in 1672. It had the same dilemma in its attribution as the *Portrait of a Lady with Pearl Hairnet* by Ambrogio de' Predis solely because of their physical vicinity. The two paintings were placed on the same wall in the mid-nineteenth century and were considered portraits of Ludovico il Moro and Beatrice d'Este.

In 1904, the decision was made to remove a layer of paint on the bottom (though it was historic and probably attributable to Leonardo himself) which covered the right hand and the piece of paper on which the lines and notes of a musical score can be seen. The man in the portrait could be identified as Franchino Gaffurio, chapel master of the Cathedral of Milan in 1484 as well as a regular at the duke's court who surely had a friendly relationship with Leonardo. Other musicians present in Milan in these same years have been suggested, including Atalante Migliorotti, who came to Milan with Leonardo; and Josquin des Préz, who also worked as chapel master of the Cathedral of Milan.

The dating of the painting, which is the only surviving portrait of a man by Leonardo, has been estimated in regards to its stylistic affinity with the *Lady with an Ermine* and *La Belle Ferronnière*.

These paintings are similar in style, the relationship of the figure to space and their exceptional psychological acuity. The power and feeling that emanate from the individual portrayed, captured in a moment of waiting (is he about to start his song?) is tied to northern portrait painting, probably filtered through familiarity with the works of Antonello da Messina who was in Milan in 1475.

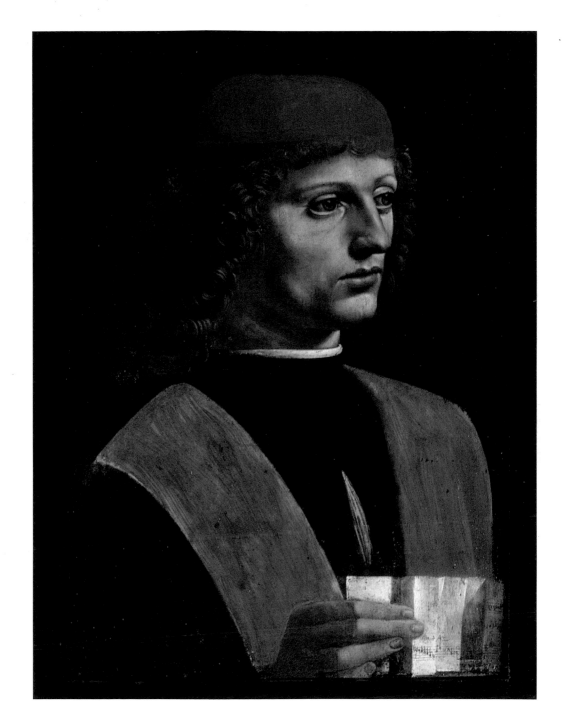

Portrait of Cecilia Gallerani
(Lady with an Ermine)

1488–1490
Oil on panel, 54.8 × 40.3 cm
Krakow, Czartoryski Museum
Top left, the apocryphal
writing LA BELE FERONIERE
LEONARD DA VINCI

Prince Adam Czartoryski had purchased this magnificent portrait toward the end of the eighteenth century for his wife Isabella, who had a kind of private museum called the Gothic House in the castle of Pulawy. In the past it has been attributed to Boltraffio and to Ambrogio de' Predis. Today Leonardo's paternity is no longer in doubt. Likewise, the theory is confirmed that the woman portrayed is Cecilia Gallerani to which the ermine would allude, in Greek Υαλη (gallé). Cecilia was born in 1465, the daughter of Fazio Gallerani, a Milanese nobleman and landowner. The woman was sixteen years old and an orphan when her lover, Duke Ludovico, gave her the estate of Saronno. With her beauty, her intelligence and the strength of her spirit she came to play a primary role in the Milanese court. Once her duke took a wife, Gallerani married Count Bergamini di Cremona and lived in Milan in the Palazzo del Broletto.

The portrait was celebrated in a sonnet by Bellincioni who died in 1492. In 1498, the portrayed showed it to Isabella d'Este so that the cultured Marquise of Mantua could compare Leonardo's way of working with that of Giovanni Bellini. Gallerani, in an exchange of letters with Isabella, reminded her that at the time of the portrait she was "so imperfect" and that now much had changed.

The turn of the figure's bust seems to happen at the moment in which one looks at the painting. The ermine also follows the gaze of the woman. Its fur is painted hair by hair. The beast seems almost frightened, but the woman's hand, which has a clear anatomy, calms it. X-rays have shown that behind the woman's left shoulder there was once a window. This is the reason for the intense light and sense of reflection that we see today.

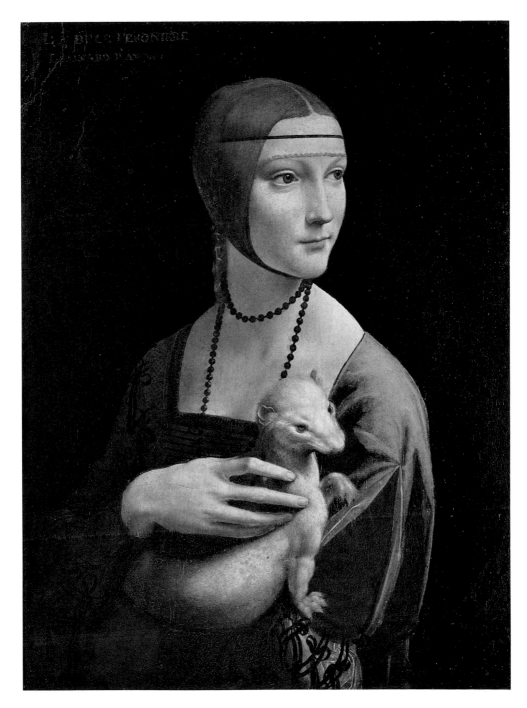

Portrait of a Lady
(La Belle Ferronnière)

c. 1490–1495
Oil on panel, 63 × 45 cm
Paris, Musée du Louvre

This painting was first mentioned in the royal collections at Fontainebleau in 1642 and, significantly, was in the *Trésor des merveilles de Fontaineblu* by Pierre Dan where it is mentioned as a portrait of the Duchess of Mantua. The painting must have historically been part of the crown collections possibly at the time of Louis XII or François I. Its origins, however, are not documented.

There have been various theories for identifying the portrayed woman, none of which, however, appear convincing. The title by which the painting is universally known, *La Belle Ferronnière*, literally "beautiful wife of a hardware merchant," is merely the result of a mistake that occurred in the eighteenth century during cataloguing when it was confused with another portrait of a lady. In the nineteenth century, a piece of jewelry similar to that worn by the woman on her forehead became popular, but it is presumed not to be originally from Leonardo's time.

Identification of the woman has vacillated between Cecilia Gallerani, Elisabetta Gonzaga and Lucrezia Crivelli. The latter was also a lover of Ludovico Moro's and, according to three epigrams found in the *Codice Atlantico* (folio 167 verso), Leonardo painted her portrait. The report adds that a little more than six months after the death of his wife, Beatrice d'Este, Ludovico made a gift to Crivelli of some lands on Lake Maggiore and Lake Como and recognized the right of succession to her son Gian Paolo, born to her in 1497.

A strong contrast is used in the painting to make the figure emerge from the background and bathe her in warm light. The woman is struck by diffuse, not direct, light, which gives her a greater sense of plasticity. The original arrangement of the lock of hair on the left check is shown by radiographic study to have been much higher, revealing her ear.

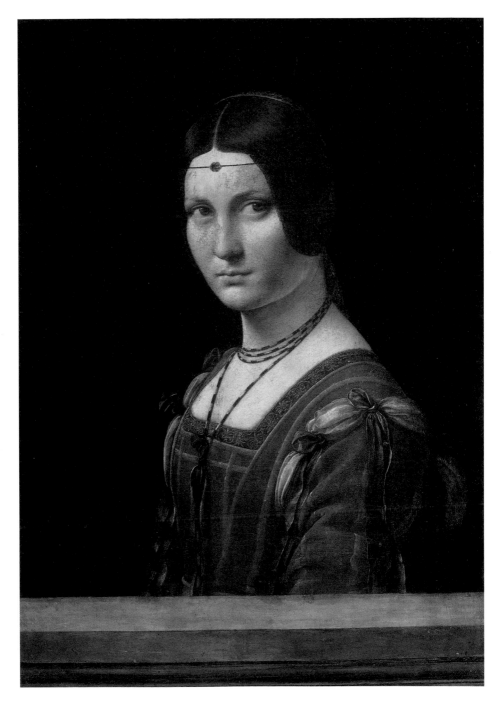

The Last Supper

1494–1497

Tempera and oil on two layers
of gesso preparation spread on
plaster, 460 × 880 cm
Milan, refectory of Santa
Maria delle Grazie

The *Last Supper* was undoubtedly a com-
mission from Ludovico il Moro, evident
by the ducal insignia in the three lunettes
above it. A request that duke made on June 29,
1497 to Marchesino Stanga, soliciting the
work's completion, provides confirmation. In
1498 it must have been completed as shown in
the letter dedicated to Ludovico il Moro with
which the *De divina proportione* by Luca Pa-
cioli opens.

The *Last Supper* is located in the refecto-
ry of the Dominican church of Santa Maria
delle Grazie in Milan. Its theme, which may
have been suggested by the Dominicans, rep-
resents the institution of Eucharist. The mo-
ment that Leonardo chose is the most dra-
matic moment in the Evangelical story, when
Christ utters the sentence, "One of you will
betray me." What Leonardo called the "mo-
tions of the soul" start from these words. The
apostles are dramatically animated, their ges-
tures are of amazement and wonder. There are
those who stand up because they did not un-
derstand Christ's words, those who near, those who are horrified,
those who withdraw, like Judas, feeling immediately accused.

The figures of the apostles are defined by their monumentality.
They are portrayed in a room which is precise in terms of perspec-
tive. Through simple perspectival devices—the framing of the floor,
the coffered ceiling, the tapestries on the walls, the three windows in
the background and the position of the table—the effect of the fres-

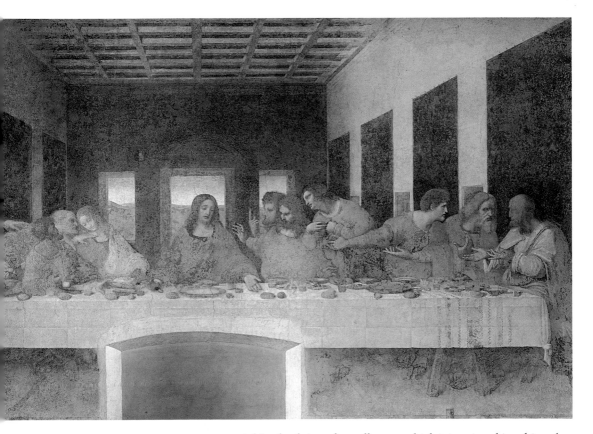

co sinking back into the wall upon which it is painted is achieved to make it appear as a room within a room of the refectory.

In its last restoration the *Last Supper* gained some details that appear endowed with a luminosity and color freshness that was not previously imagined. The color is used in the tones of light. The source of this light is a real window of the refectory and the three windows painted in the background that open on a sky about to darken.

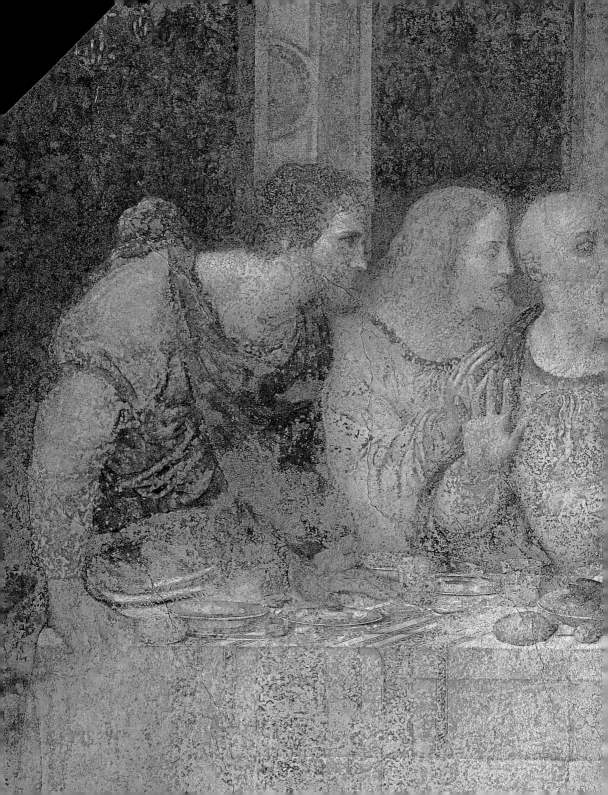

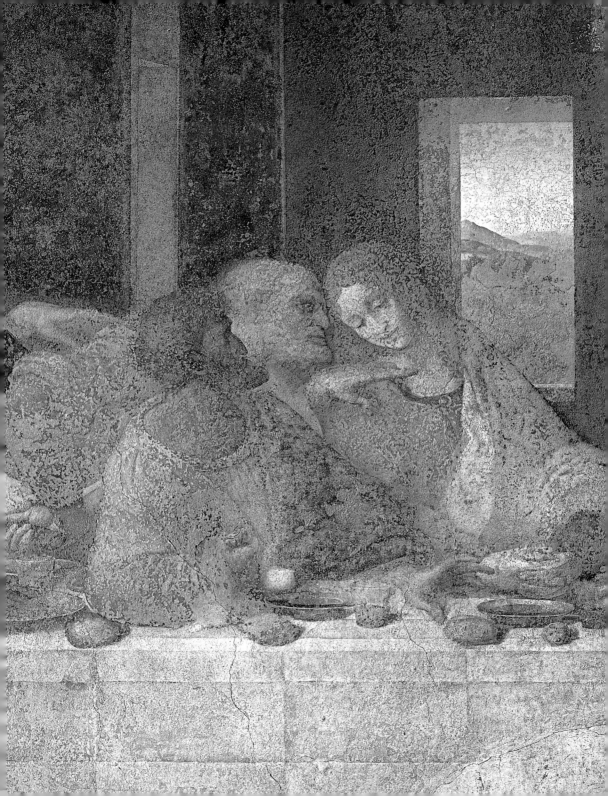

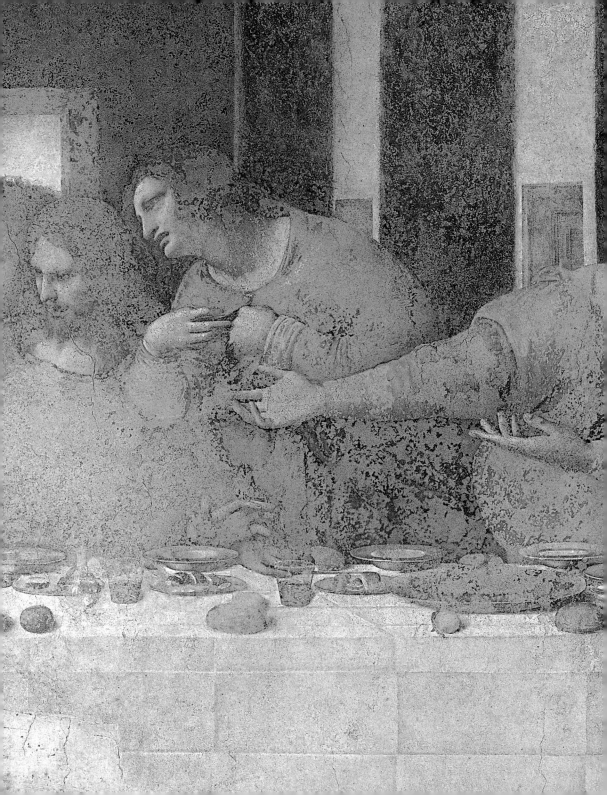

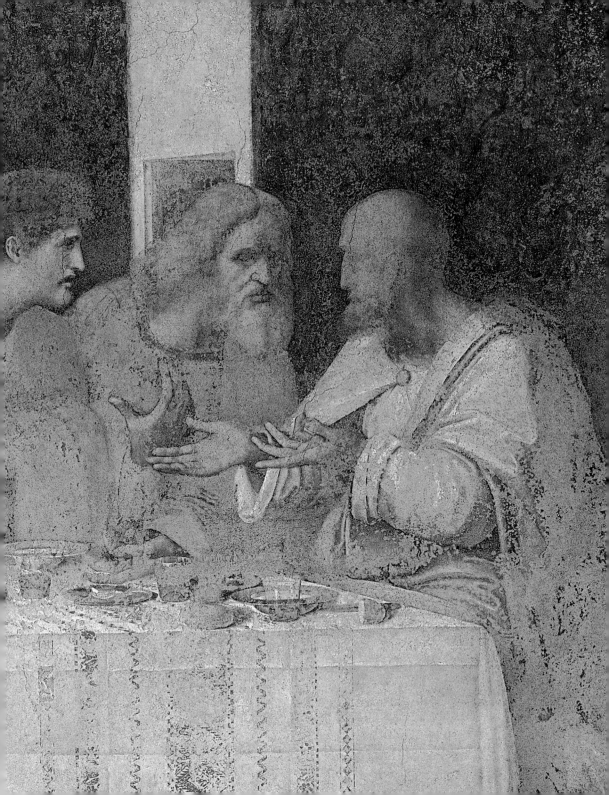

The Virgin with the Infant Saint John Adoring the Infant Christ Accompanied by an Angel (Virgin of the Rocks, second version)

1495–1508
Oil on panel, 189.5 × 120 cm
London, National Gallery

The painting was purchased in 1785 by the painter Gavin Hamilton for 112 Roman sequins. Previously, it had been on the altar of the Compagnia della Concezione in San Francesco Grande in Milan. It came to the London National Gallery in 1880 after having passed through two other English collections. The work is in large part by Leonardo's own hand and is a second version of a painting commissioned to Leonardo in 1483. This version was conceived by Leonardo himself with many differences from the painting in Paris. The figures are larger, their clothes are simplified, giving them greater monumentality. There are echoes of the heights reached in the majestic apostles in the refectory of Santa Maria delle Grazie. In reformulating the angel, the artist chose to do away with the gesture of the pointing hand and to give his expression greater power, as he is concentrated within himself; the Christ child does not have the same moral intensity. The infant Saint John and the Virgin, though they are in a similar position, are given a higher concentration of shadows that make them somewhat less lyrical. The configuration of rocks is almost identical in the two paintings, while the light of the sky in the back and the water plants in the London version are a completely different species.

The painting was prepared and started by Leonardo with the help of his student Ambrogio de' Predis under the master's supervision. It was painted to replace the original. The two versions come from the same altar, but from different times. This painting, compared to the Paris version, shows a simplification of the iconographic and symbolic concepts, figures with a more pronounced chiaroscuro and a cooler color tone.

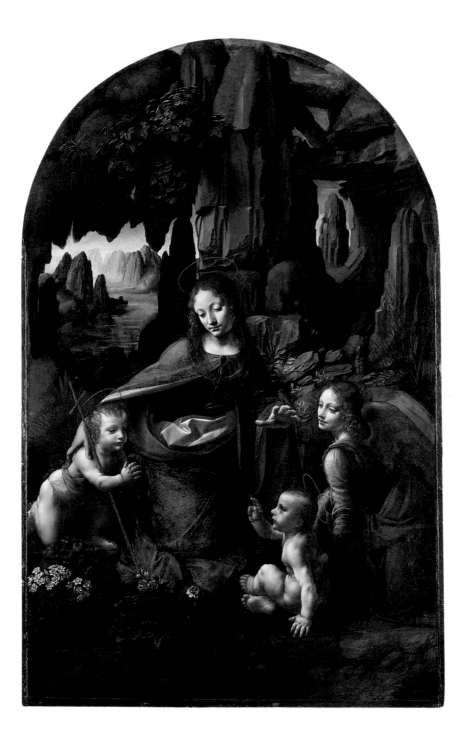

126

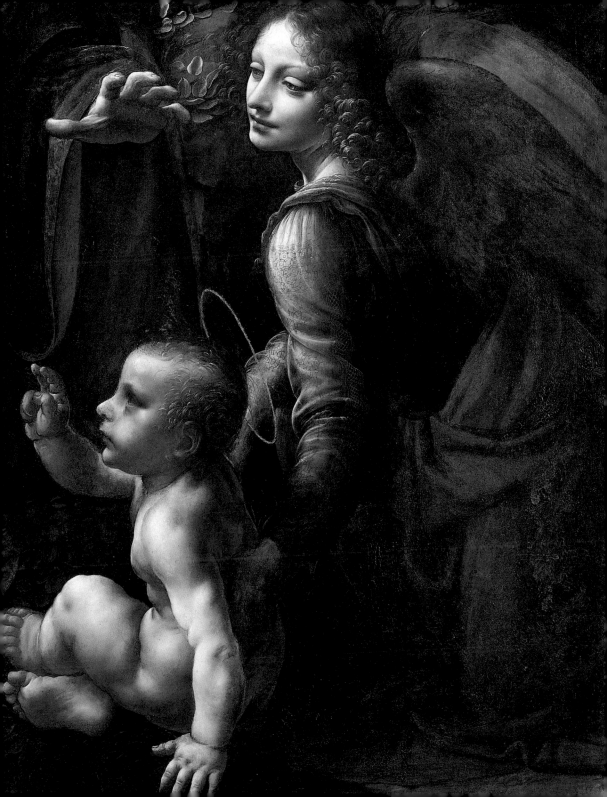

Tree Trunks with Branches, Roots and Rocks

1498
Pen drawing on plaster,
fragments
Milan, Castello Sforzesco,
Sala delle Asse

The only documented evidence of the decoration of this room is a letter from Gualtiero da Bascapè to Ludovico il Moro, dated April 21, 1498. We know that Leonardo undertook the decoration of "certain little rooms" and "a small black hall" in the Sforzesco Castle, but the Sala delle Asse is the only surviving room.

The remains of the two large monochrome drawings on the eastern wall of the hall were already discovered in 1893–1894 when work as undertaken at the request of Paul Müller Wolde to uncover from the faint light of the northeast hall of the Sforzesco Castle the existence of works by Da Vinci. The vault was totally repainted by Ernesto Rusca in 1901–1902 and the two monochromes were covered by wooden boards because they were not thought to be by Leonardo. They were then only "rediscovered" in 1954 and since then have been considered by critics as the only part of the entire decoration by his hand.

The vault is structured as an architectonic labyrinth, bringing to mind the pavilions that Leonardo created in the castle's park to decorate the duke's feasts. The blue sky is still visible between the intertwining of the branches. It must have originally been bright and atmospheric. The large roots slip themselves between layered rocks until they expand into a large base full of protuberances that become the start of a tree trunk. Leonardo probably planned it as the basis for a decoration that covered the hall, including the walls, to create a single environment from the base to the end of the vault. The ways in which the roots slip themselves between the gaps of the rock has a strong dynamic power. It is the very power of nature that is released from the roots, as if a catastrophic event were triggered, a suggestion of primordial powers that are about to be unleashed.

Portrait of Isabella d'Este

1500
Black chalk, sanguine
and yellow pastel on paper,
63 × 46 cm
Paris, Musée du Louvre,
Cabinet des Dessins

The cartoon came from the Vallardi collection and entered the Louvre in 1860. The Paris portrait never enjoyed much critical success because it was derived from a heraldic model, a medal made by Gian Cristoforo Romano in 1498. It is said that the marquise Isabella d'Este did not like to pose for portraits, yet, judging by how many times she sent for Leonardo to paint her one, just the opposite seems the case. When Lorenzo Gusnasco compared this cartoon with the portraits painted by Giovanni Bellini, those portraits seemed, though luminous and noble, to pale in comparison.

This work can be interpreted as a testament to the words that Cecilia Gallerani wrote to Isabella about Leonardo's excellence as a portraitist. Here he shows himself more mature than when he painted her portrait. Leonardo was interested early on in representing the human face and body. In this cartoon he studied at length the best light that could render the gracefulness of the face, emphasizing the description of "the motions of the mind." The marquise's portrait, though it remained a preparatory cartoon, was clearly a precedent of the portrait of *Mona Lisa*. It may even be better constructed than the *Mona Lisa*, whose figure does not seem to dominate the foreground with as much authority, nor can such a strong rotation of the bust seen in it. The face is not expressive such as that in the *Portrait of a Musician* or as in the so-called *La Belle Ferronnière* but we can recognize some of the greatness achieved by the artist in the weight of the bodies in the *Last Supper*.

Along the lines that give body to the sumptuous clothes, we can see minute holes intended to let the very fine carbon powder filter on the canvas which would have constituted the base outline of the painting.

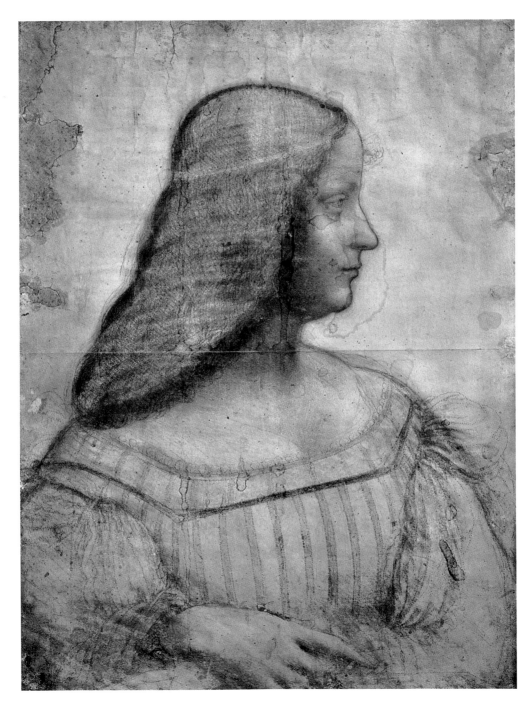

Virgin and Child with Saint Anne and Saint John the Baptist (Burlington House Cartoon)

1501(?)–c.1505
Black chalk, ceruse and stump on paper, 141.5 × 104,6 cm
London, National Gallery

The cartoon was owned by the Arconati family of Milan in the eighteenth century and then went to Venice where it was sold to Robert Udny in 1763. After having passed through Burlington House and the Royal Academy, it came to the National Gallery of London in 1966.

The cartoon is stylistically close to the *Last Supper* and gives the same impression of strength that the apostle's figures do. It doubtlessly represents the most classically influenced piece in Leonardo's œuvre to the extent that some critics say that the grandness of these figures was inspired by a classical sculpture. Leonardo made an effort to reproduce a multicentric sense of movement, making the two characters blend into a single complex, on top of which is Saint Anne's head. The cartoon is, rightfully so, judged superior to the painted version in the Louvre. In the drawing, studies for it and particularly in one kept in the Louvre, it is clear that Leonardo intended to make a mirror image of the same cartoon already used for the right hand of Peter in *Last Supper*. The Louvre holds several drawings that mark the development of the cartoon and clarify how Leonardo thought about its composition.

Three generations of Christ's family are represented. Saint Anne holds her daughter Mary on her knees and Mary holds her son who is turned toward infant Saint John. The harmony of the image's forms and the lyricism contained in its feelings makes it one of the artist's most sublime paintings.

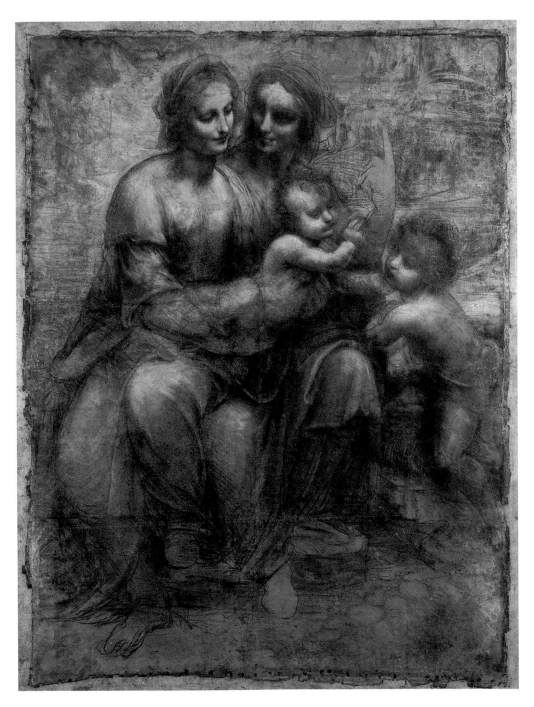

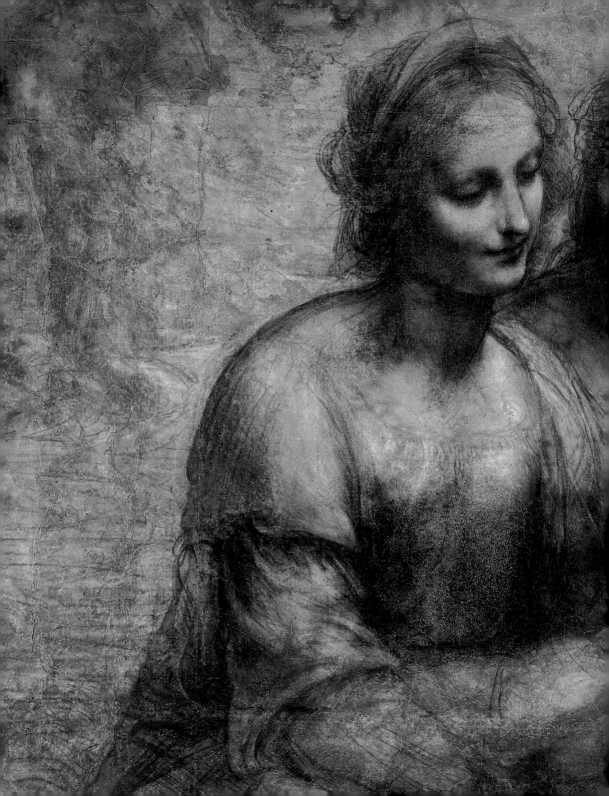

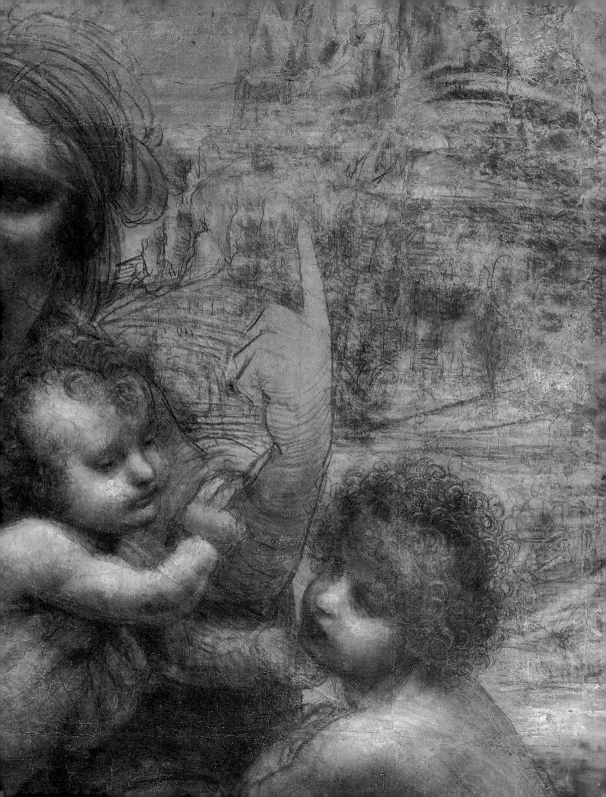

Portrait of Mona Lisa del Giocondo (La Gioconda)

1503–1504 and 1510–1515
Oil on panel, 77 × 53 cm
Paris, Musée du Louvre

The first time period comes from the identification of the subject with Lisa del Giocondo, wife of the Florentine merchant Francesco del Giocondo, according to Giorgio Vasari. The second set of dates comes out of the stylistic study of the landscape. The conception of the work can be taken back to the second Florentine period, but it may have been completed *ad istantia del quondam magnifico Juliano de Medici* in Rome between 1510–1515.

Sources say that Leonardo brought this painting with him when he moved to France to the Cloux castle near Amboise in the service of King François I. Antonio de Beatis, secretary to the Cardinal d'Aragon, saw it in his studio when he went to visit Leonardo in October of 1517. Salaì, his favorite pupil, inherited it and brought it to Milan where it was inventoried among his goods in 1525, a year before his death. Vasari mentioned it as already in Fontainebleau in the collection of François I (who died in 1547) and it is discussed here with certainty by Cassiano dal Pozzo in 1625. The pictorial quality of the classic bust portrait is extremely high. It is a work without precedents in the field of portrait painting for its strong psychological introspection that the face expresses, partly through her sardonic smile. The painting is pervaded by a tonal, warm and diffuse light which surrounds all of the elements it portrays: the flesh, the clothing, the waters, the rocks and the atmosphere. This effect may be caused by the yellowing of the paints. The image is such that catalyzes the gaze of the observer provoking mystical and sensual feelings; we can say everything and the opposite of everything about it. The bust, seen in three-quarter view, recedes toward the background. The lady is seated in a loggia of which we can see on the left the base of a column. The landscape that takes shape over her shoulders consists of waters and mountains that seem like a glacial and remote atmosphere.

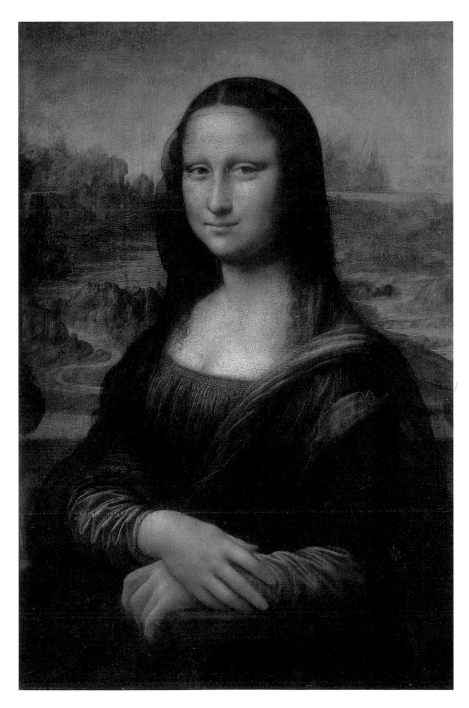

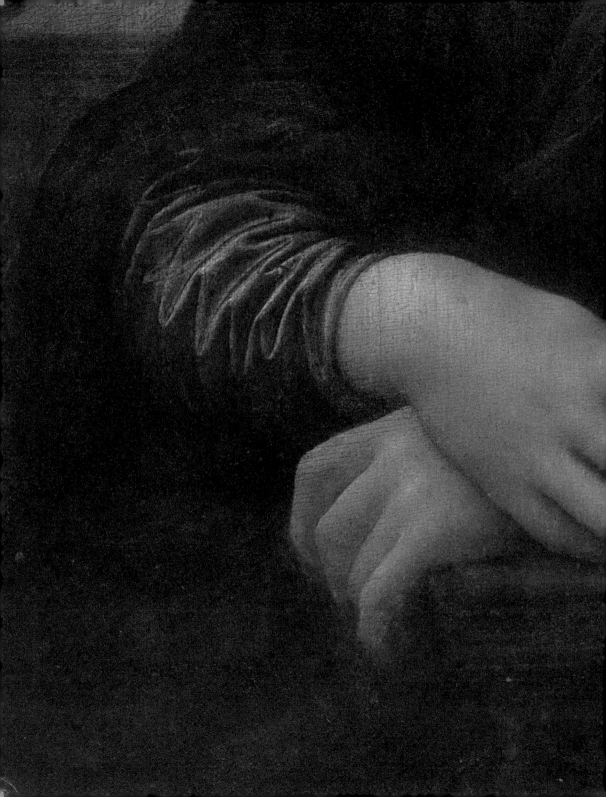

Female Head
(La scapigliata)

c. 1508
Earth shadow, green amber
and ceruse on panel
24.7 × 21 cm
Parma, Galleria Nazionale,
Palazzo Pilotta

Adolfo Venturi identified this painting with the one that Ippolito Calandra proposed in 1531 to be placed in the bedroom of Margherita Paleologa, wife of Federico Gonzaga, which was described in 1627 in Gonzaga's inventory as "a painting portraying the head of a disorderly (*scapigliata*) woman, […] a work of Leonardo da Vinci." The heirs of Gaetano Callani, a brilliant painter and sculptor from Parma, gave it to the Accademia di Belle Arti di Parma in 1826. There were those who claimed that the work was a counterfeit by Callani himself.

The painting was left incomplete, but some parts of the face are quite complete and can easily be referenced to Da Vinci's œuvre. Although a study was published in 1939 certifying this painting as by Leonardo's hand, critics have shown little interest in it. Doubts of its authenticity aside, there are still questions about its chronological placement. It is not clear if this is an early work, which can be related in its style and technique to the drafts for the *Adoration of the Magi* and *Saint Jerome*, or a later work, in which the classicism that Leonardo learned on his Roman trips in the early sixteenth century can be seen. In fact, in the first decade of the sixteenth century, Leonardo revisited his early experiences to attempt a new way of seeing and perceiving form in a more volumetric manner. This face exudes the sense of ambiguity and realism typical in Leonardo's works. The face's position, slightly inclined to the right, can be compared to the studies for the hairstyle of *Standing Leda*, which interested the artist in the first decade of the sixteenth century. Specifically, there is a close relationship to a page now in the Royal Library of the Windsor Castle portraying a woman's head with an elaborate hairdressing.

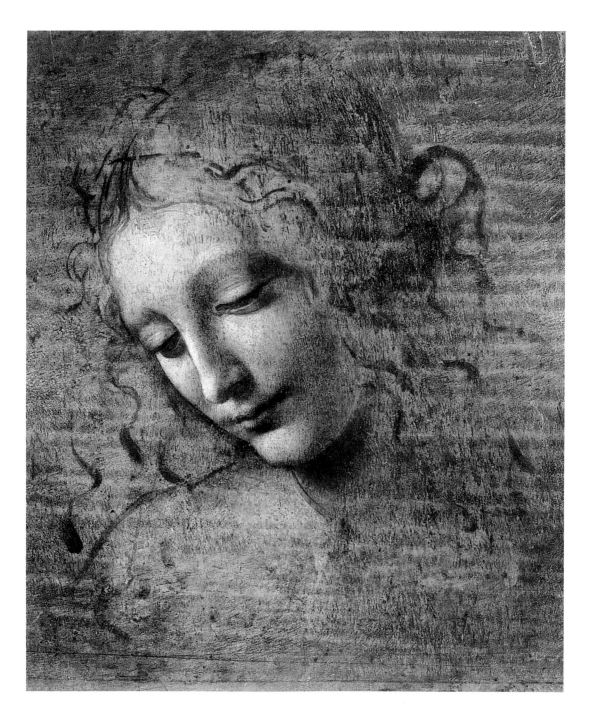

143

Saint John the Baptist

c. 1508–1513

Oil on panel, 69 × 57 cm

Paris, Musée du Louvre

This painting was also seen in Leonardo's studio in Cloux in 1517. It was then inherited by Salaì, in whose inventory it appeared in Milan in 1525. As with the other paintings, this must have been sold by Leonardo's heirs as it appears in E. Jabach's collection. It was then given to Louis XIV in 1666 and was then given to the Louvre.

The saint is portrayed as a half bust, a variation on the theme of the figure classically and monumentally constructed in space in direct reference to the models of statues of antiquity. The painting can be considered completely by Leonardo's hand. The figure is wrapped in a soft shadow. His face carries a languid and ambiguous expression typical of the master's later works. The shading, that somewhat weighs down the image is used intensely. Leonardo employs chiaroscuro to give relief to the painting surface. Relief is nothing other than that produced by the optical relationship between an object and its background (a theory often expressed in his writing).

Today the work has blackened. Despite this, on the walls in the shadow there is some reflection of light, primary and secondary shadows. The softness with which the tonal transitions are accomplished from one contour of the face to the other shows Leonardo's interest for atmospheric subtleties. The painting's theme is light, optical and expressive light. "No one has ever denied that an intense aura of emotional engagement exudes from Saint John. Its nature has however been interpreted in a variety of ways and often in ways unfavorable to Leonardo. In the worst case, it has been seen as the effusion of an ageing homosexual, and from a certain perspective, that may be true" (Kemp, 1982).

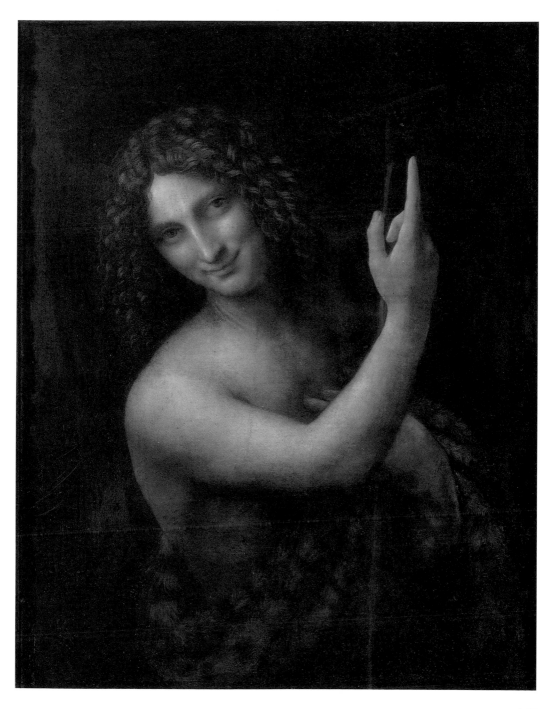

The Virgin and Child with Saint Anne
and the Little Lamb

c. 1510–1513
Oil on panel, 168 × 130 cm
Paris, Musée du Louvre

Antonio de Beatis saw this painting in Cloux on his 1517 visit, which we have already mentioned. His pupil Salaì brought it to Milan. In 1629, the painting was bought at Casale Monferrato, during the war for Mantua's succession, by Cardinal Richelieu, who gave it to the king of France, Louis XIII, in 1636. It has been in the Louvre since 1810.

Leonardo worked on this theme several times, at least since he made the cartoon for the Serviti of Santissima Annunziata in Florence. The grouping is formed following a perfectly balanced pyramid structure. The Christ child flees from the mother's arms and grabs the lamb by the ears. Mary, who is sitting on her mother Anne's lap, tries lovingly to stop him from this game. The scene is homey, playful and peaceful. Behind the group is a view of a mountainous landscape that is so evanescent that it seems magical and unreal, timeless and ageless. The doubts expressed in the past about it having been painted by Leonardo stem from its imperfect state of conservation. The opaque flatness of the Virgin's clothes is caused more by the deterioration of the pigment rather than by Leonardo not having finished painting this area. Saint Anne's clothes have also lost color and the tree to the right that serves as a theatrical backdrop has nothing of the naturalism we expect in Leonardo's works. The layering of the rocks and stones in the foreground is what has remained of an edge of a pool of water that originally bathed the feet of the saint (a device that Leonardo also used in his early works). The draping of the arm of the Virgin's clothes reveals those considerations on which the artist had practiced in his studies and drawings. They can also be referenced to the interest, that he had often explored, in comparisons with classical statues.

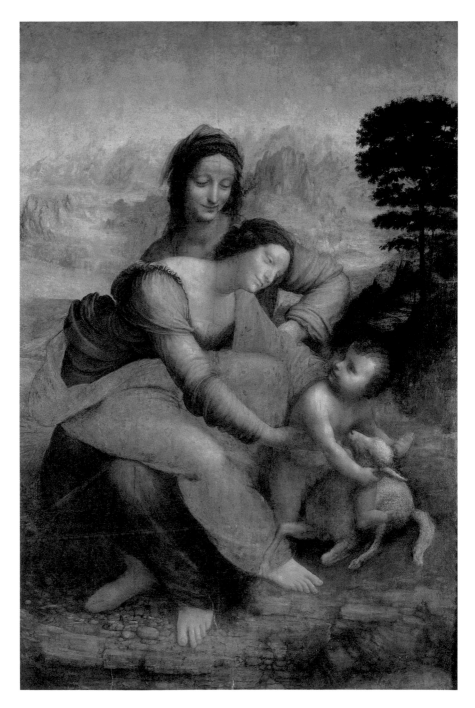

Bacchus

1510–1515 (?)
Tempera and oil on panel
transferred to canvas
177 × 115 cm
Paris, Musée du Louvre

This painting was inherited by Leonardo's fortunate pupil Salaì and was seen by Cassiano dal Pozzo in Fontainebleau in 1625, defined as a "Saint John in the desert." It was recorded in 1695 in the royal collections as *Baccus dans un paisage* (Bacchus in a landscape). It had the same fate as the other works Leonardo had in his studio, going from France to Milan to return finally to Paris.

Some critics believe that the painting originally represented a Saint John the Baptist in the desert. In support of this theory, scholars cite the fact that the addition of the attributes of Bacchus (the crown of vine leafs, the panther skin and the grape bunch) were made in the French collections between 1683 and 1695. There are two copies of this work: one by Cesare da Sesto's and the other in the church of Sant'Eustorgio in Milan. Neither of the two has the Bacchus attributes. However, a derivation found in Worcester by Andrea del Sarato, in which Leonardo's authority is palpable, does show these attributes. It is therefore difficult to establish if the *Bacchus* in the Louvre was originally a Saint John/Bacchus or if the attributes were added later and without Leonardo's intentions. The character is located in a natural surrounding and once again returns to the theme of a classical style figure. Of course, to be a Saint John the Baptist the figure does not have a cross, but a thyrsus. "Despite its poor state of conservation, this strange painting has its own unique charm, as a nostalgic image of a lost paradise."

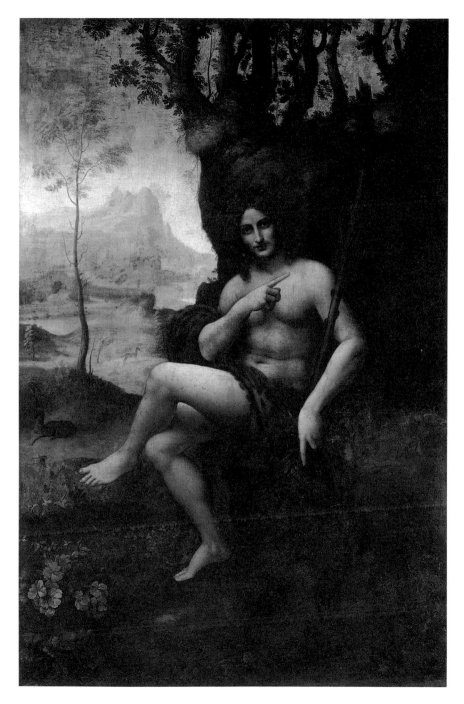

Leda
(after Leonardo)

c. 1515–1520
Tempera grassa on panel
112 × 86 cm
Rome, Galleria Borghese

At the time of its inventory, *Leda* was the most highly valued painting inherited by Gian Giacomo Caprotti, better known as Salaì, a sign of its considerable fame. It was almost certainly the *Standing Leda* version of which this painting is a derivation by a Leonardo follower who must have seen its cartoon in addition to copying the original. In 1625, Cassiano dal Pozzo described Leonardo's *Leda* in Fontainebleau as, "A standing Leda, almost completely nude, with the swan and two eggs at her feet and a figure from the shell of which four children are seen emerging." Its conception dates to the second Florentine period, at the same time as his studies for the *Battle of Anghiari*.

Leonardo's choice to give life to a classical myth such as that of Leda (with undeniable erotic and sensual implications) should be interpreted as one of the infinite proofs of his interest for antiquity, an interest that became more ardent after his Roman trip in the first years of the sixteenth century.

This painting appeared in the inventory of the Galleria Borghese beginning in 1693 with an attribution to Leonardo. Of the many surviving copies (a dozen in all) this and the former Spiridon version, now in the Galleria degli Uffizi in Florence, were those which had longest maintained the attribution to Leonardo. "The Leda's powerful anatomy, the mastery of the expressive means of the layout of the background, with the tiny black outlines that populate the urban center following a pure Florentine tradition, lead to a more likely attribution of the work to an artist in the Tuscan area, who was strongly influenced by Flemish realism" (Bartoli, in *Leonardo e Il Mito di Leda*, 2001).

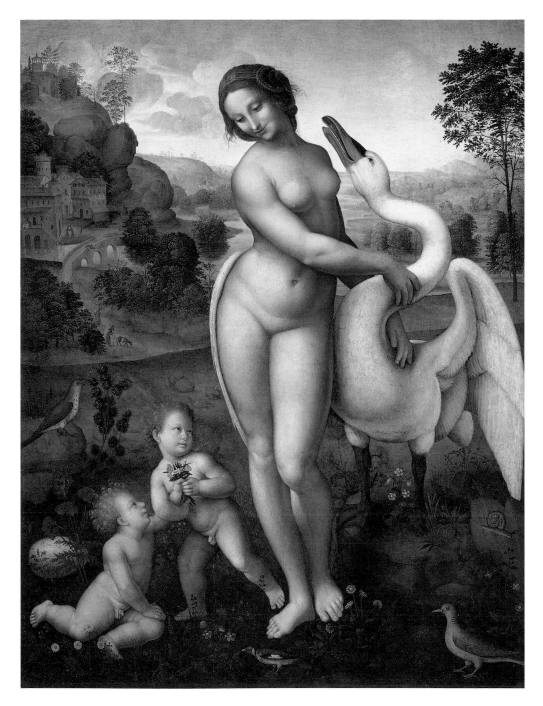

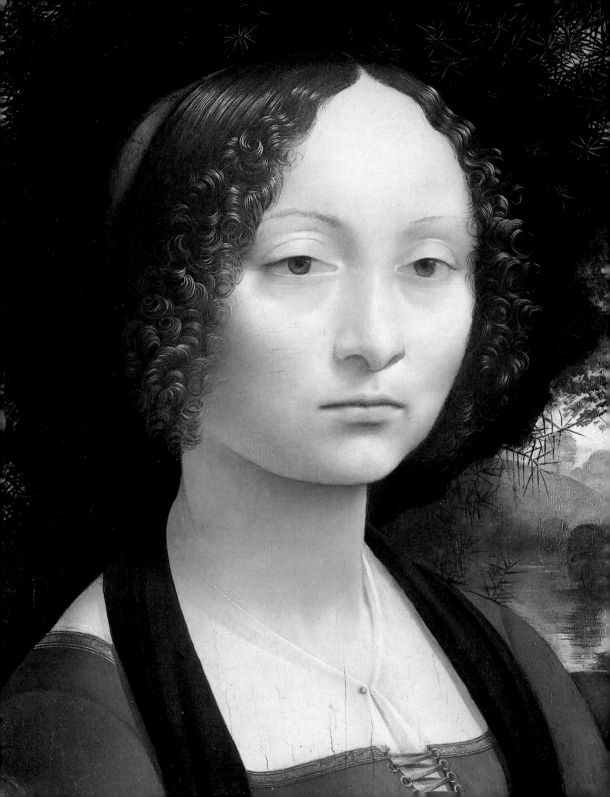

Appendix

Ginevra de' Benci
(detail), *c.* 1474–1476
Washington, D.C., National Gallery
of Art

Chronological Table

	Life of Leonardo	Historical and Artistic Events
1452	Leonardo was born in Vinci on April 15, the natural son of notary, Piero di Antonio.	In Arezzo, Piero della Francesca begins the cycle of frescoes with the *Legend of the True Cross*.
1454		The Peace of Lodi initiates a period of political stability in Italy.
1469	In this year, he was already in Verrocchio's workshop.	
1472	He is a member of the painter's guild, the Compagnia di San Luca. His first works date from this time: sets for feasts and tournaments, a cartoon for a tapestry (destroyed) and paintings of uncertain dating.	
1473	Dates (August 5) the drawing *Landscape of the Val d'Arno* (Florence, Uffizi).	
1476	He and others are accused of sodomy. He is acquitted.	In Milan, Galeazzo Maria Sforza is assassinated in a plot. His son Giangaleazzo succeeds him; the city is governed by Simonetta.
1478	He is commissioned to paint the altarpiece for the Chapel of San Bernardo in Palazzo della Signoria. In the same year, he says he completed two paintings of the Virgin, one of which is now identified as the *Benois Madonna*.	The Pazzi Conspiracy, instigated by Pope Sixtus IV, fails; Giuliano de' Medici dies, but the authority of his brother, Lorenzo the Magnificent, is strengthened.
1480	According to the "Anonimo Gaddiano," he works for Lorenzo de' Medici.	Ludovico Sforza kills Simonetta, imprisons his nephew and illegitimately becomes duke of Milan.
1481	Contract for the *Adoration of the Magi*.	
1482	He moves to Milan leaving the *Adoration of the Magi* unfinished.	
1483	In Milan, he signs the contract for the *Virgin of the Rocks* together with Evangelista and Ambrogio de' Predis.	Raphael is born in Urbino.

	Life of Leonardo	Historical and Artistic Events
1487	Payment for projects for the tiburio of Milan's Duomo.	
1488		Verrocchio dies in Venice, where he was working on the equestrian monument of Colleoni. Bramante is in Pavia, where he is consulted for the Cathedral's design.
1489	He designs temporary sets to celebrate the marriage between Gian Galeazzo Sforza and Isabella d'Aragona. In this same year, he begins preparations for the colossal equestrian statue in honor of Francesco Sforza.	
1491	Gian Giacomo Caprotti from Oreno, known as Salaì, eleven years old at this time, enters into Leonardo's service. His nickname Salaì, which means "devil," comes from the boy's unruly character.	
1492	He designs the costumes for the procession of Scythians and Tartars for the marriage between Ludovico il Moro and Beatrice d'Este.	Lorenzo de' Medici dies in Florence. The system of alliances formed by the Peace of Lodi starts to break up.
1494	Reclamation works on one of the duke's estates near Vigevano. Begins the *Last Supper*.	Charles VIII, king of France, allied with Ludovico il Moro, comes to Italy to reclaim his rights over the Kingdom of Naples.
1495	He begins decoration of the rooms in the Sforzesco Castle. The artist is mentioned as a Ducal Engineer.	
1497	The duke of Milan urges the artist to complete the *Last Supper* which was probably finished at the end of the year.	
1498	Completes the decoration of the Sala delle Asse in the Sforzesco Castle.	Pollaiolo dies in Rome, where he had made the tombs of Sixtus IV and Innocent VIII. Michelangelo is commissioned to sculpt the *Pietà* in St. Peter's. Savonarola is burned at the stake in Florence.

	Life of Leonardo	Historical and Artistic Events
1499	Leaves Milan in the company of Luca Pacioli. He stops first at Vaprio to visit Francesco Melzi, and then continues to Venice passing through Mantua, where he paints two portraits of Isabella d'Este.	Luca Signorelli begins the frescoes in the chapel of San Brizio in the Cathedral of Orvieto. Milan is occupied by the king of France, Louis XII.
1500	He arrives in Venice in March. Returns to Florence and stays at the monastery of the Servite Brothers at Santissima Annunziata.	Piero di Cosimo paints the *Stories of Primitive Humanity* in Florence.
1502	Enters into Cesare Borgia's service as architect and general engineer, following him in his military campaigns in Romagna.	In Rome, Bramante begins the temple of San Pietro in Montorio and the Belvedere Courtyard.
1503	Returns to Florence where, according to Vasari, he paints *Mona Lisa* and *Leda*. He draws up plans to deviate the course of the Arno during the siege of Pisa. The Signoria commissions him to paint the *Battle of Anghiari*.	
1504	Continues to work on the *Battle of Anghiari*. He is asked to be part of the committee to decide where to place Michelangelo's *David*.	Michelangelo completes the David commissioned three years earlier by the Republic of Florence. Raphael paints the *Marriage of the Virgin*. He then moves to Florence where he is profoundly influenced by Leonardo's works.
1506	He leaves Florence for Milan, committing to return within three months. The stay in Milan lasts longer than planned.	
1508	He lives in Florence and then returns to Milan.	In Rome, Michelangelo starts to fresco the vault of the Sistine Chapel. In Venice, Giorgione and Titian fresco the Fondaco dei Tedeschi.
1509	Geological studies of the Lombardian valleys.	Raphael is in Rome, where he starts to decorate the Vatican Stanze.
1510	Anatomy studies with Marcantonio Torre at the University of Pavia.	
1512		Michelangelo completes the frescoes on the vault of the Sistine Chapel.

	Life of Leonardo	Historical and Artistic Events
1513	Leaves Milan for Rome, where he stays at the Vatican, in the Belvedere, under the protection of Giuliano de' Medici. He remains in the city for three years, working on mathematical and scientific studies.	Pope Julius II dies. Giovanni de' Medici succeeds him with the name Leo X. In Florence, Andrea del Sarto begins the fresco cycle with *Stories of the Virgin*. In Milan, Cesare da Sesto achieves a synthesis of Leonardo and Raphael's styles with his Baptism of Christ.
1514	Projects for draining Pontine swamps and for the port of Civitavecchia.	Bramante dies in Rome. Raphael succeeds him as architect of the Fabric of St. Peter.
1515		François I becomes king of France. He reconquers Milan with the victory of Marignano. Raphael works on the cartoons for the tapestries in the Sistine Chapel.
1516	He moves to Amboise, to the court of François I of France.	Charles of Hapsburg becomes king of Spain.
1517		In Rome, Raphael and his workshop paint the Logge in the Vatican and the Loggia of Psyche in the Villa Farnesina.
1518	Participates in the festivities for the baptism of the Dauphin and Lorenzo de' Medici's marriage to the king's niece.	
1519	On April 23, he revises his will. His friend, the painter Francesco Melzi, is the will's executor. He dies on May 2.	Charles V of Hapsburg is named Holy Roman Emperor. Direct conflict begins between France and the Empire. In Parma, Correggio paints the Badessa's Chamber in the Convent of San Paolo.

Geographical Locations of the Paintings

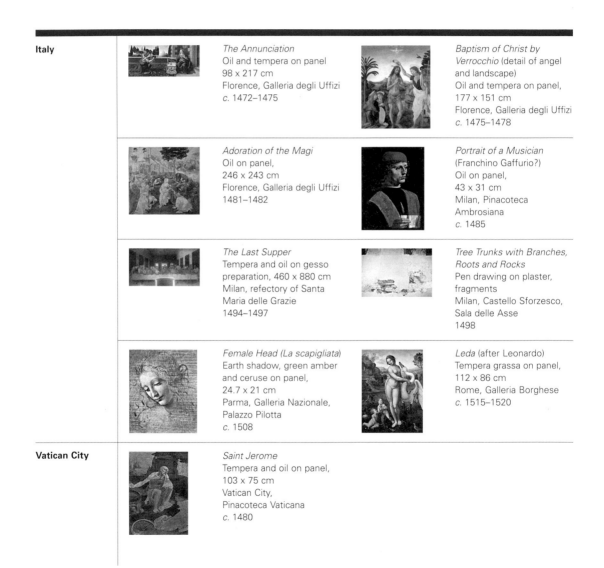

Italy

The Annunciation
Oil and tempera on panel
98 x 217 cm
Florence, Galleria degli Uffizi
c. 1472–1475

*Baptism of Christ by
Verrocchio* (detail of angel
and landscape)
Oil and tempera on panel,
177 x 151 cm
Florence, Galleria degli Uffizi
c. 1475–1478

Adoration of the Magi
Oil on panel,
246 x 243 cm
Florence, Galleria degli Uffizi
1481–1482

Portrait of a Musician
(Franchino Gaffurio?)
Oil on panel,
43 x 31 cm
Milan, Pinacoteca
Ambrosiana
c. 1485

The Last Supper
Tempera and oil on gesso
preparation, 460 x 880 cm
Milan, refectory of Santa
Maria delle Grazie
1494–1497

*Tree Trunks with Branches,
Roots and Rocks*
Pen drawing on plaster,
fragments
Milan, Castello Sforzesco,
Sala delle Asse
1498

Female Head (La scapigliata)
Earth shadow, green amber
and ceruse on panel,
24.7 x 21 cm
Parma, Galleria Nazionale,
Palazzo Pilotta
c. 1508

Leda (after Leonardo)
Tempera grassa on panel,
112 x 86 cm
Rome, Galleria Borghese
c. 1515–1520

Vatican City

Saint Jerome
Tempera and oil on panel,
103 x 75 cm
Vatican City,
Pinacoteca Vaticana
c. 1480

France

The Virgin with the Infant
Saint John Adoring the Infant
Christ Accompanied by an
Angel (Virgin of the Rocks)
Oil on panel, 199 x 122 cm
Paris, Musée du Louvre
1483–1486

Portrait of a Lady
(La Belle Ferronnière)
Oil on panel,
63 x 45 cm
Paris, Musée du Louvre
c. 1490–1495

Portrait of Isabella d'Este
Black chalk, sanguine
and yellow pastel on paper,
63 x 46 cm
Paris, Musée du Louvre,
Cabinet des Dessins
1500

Portrait of Mona Lisa del
Giocondo (La Gioconda)
Oil on panel,
77 x 53 cm
Paris, Musée du Louvre
1503–1504 and 1510–1515

Saint John the Baptist
Oil on panel,
69 x 57 cm
Paris, Musée du Louvre
c. 1508–1513

The Virgin and Child
with Saint Anne and
the Little Lamb
Oil on panel, 168 x 130 cm
Paris, Musée du Louvre
c. 1510–1513

Bacchus
Tempera and oil on panel
transferred to canvas,
177 x 115 cm
Paris, Musée du Louvre
1510–1515 (?)

Germany

Madonna and Child
(Madonna of the Carnation)
Oil on panel,
62 x 47.5 cm
Munich, Alte Pinakothek
c. 1470

Great Britain	*Virgin of the Rocks* (second version) Oil on panel, 189.5 x 120 cm London, National Gallery 1495–1508	*Burlington House Cartoon* Black chalk, ceruse and stump on paper, 141,5 x 104 cm London, National Gallery 1501 (?) – *c.* 1505
Poland	*Portrait of Cecilia Gallerani (Lady with an Ermine)* Oil on panel, 54.8 x 40.3 cm Krakow, Czartoryski Museum 1488–1490	
Russia	*Madonna with Child (Benois Madonna)* Oil on panel transferred to canvas, 48 x 31 cm St. Petersburg, The State Hermitage Museum *c.* 1478–1482	
USA	*Madonna of the Pomegranate (Dreyfus Madonna)* Oil on panel, 15.7 x 12.8 cm Washington, D.C., National Gallery of Art, Kress Collection *c.* 1469	*Ginevra de' Benci* Tempera and oil on panel, 38.8 x 36.7 cm Washington, D.C., National Gallery of Art *c.* 1474–1476

Writings

Extracts from the notebooks of Leonardo da Vinci.

THE DIFFERENCE BETWEEN PAINTING
AND SCULPTURE

I do not find any other difference between painting and sculpture than that the sculptor's work entails greater physical effort and the painter's greater mental effort. The truth of this can be proved; for the sculptor, carving in his statue out of marble or other stone wherein it is potentially contained, has to take off the superfluous and excessive parts with the strength of his arms and the strokes of the hammer—a very mechanical exercise causing much perspiration, which, mingling with the grit, turns into mud. His face is pasted and smeared all over with marble powder, making him look like a baker, he is covered with minute chips as if emerging from a snowstorm, and his dwelling is dirty and filled with dust and chips of stone.

How different the painter's lot—we are speaking of first-rate painters and sculptors—for the painter sits in front of his work at perfect ease. He is well dressed and handles a light brush dipped in delightful color. He is arrayed in the garments he fancies, and his home is clean and filled with delightful pictures, and he often enjoys the accompaniment of music or the company of men of letters, who read to him from various beautiful works to which he can listen with great pleasure without the interference of hammering and other noises.

Moreover, the sculptor in completing his work has to draw many outlines for each figure in the round so that the figure should look well from every aspect. And these contours are composed of protrusions and depressions flowing into one another, and can only be correctly drawn when viewed from a distance whence the concavities and projections can be seen silhouetted against the surrounding atmosphere. But this cannot be said to add to the difficulties of the sculptor, considering that he, as well as the painter, has an accurate knowledge of all the outlines of objects from every aspect and that this knowledge is always at the disposal of both the painter and the sculptor [...].

The sculptor says that if he takes off too much he cannot add on, like the painter. To this we reply that if he were proficient in his art he would, with his knowledge of the required measures, have taken off just enough and not too much. His taking away is due to ignorance, which makes him take off more or less than he should.

THE PAINTER HAS THE UNIVERSE
IN HIS MIND AND HANDS

If the painter wishes to see enchanting beauties, he has the power to produce them. If he wishes to see monstrosities, whether terrifying, or ludicrous and laughable, or pitiful, he has the power and authority to create them. If he wishes to produce towns or deserts, if in the hot season he wants cool and shady places, he can make them. If he wants valleys, if from high mountaintops he wants to survey vast stretches of country, if beyond he wants to see the horizon on the sea, he has the power to create all this; and likewise, if from deep valleys he wants to see high mountains or from high mountains deep valleys and beaches. Indeed, whatever exists in the universe, whether in essence, in act, or in the imagination, the painter has first in his mind and then in his hands. His hands are of such excellence that they can present to our view simultaneously whatever well-proportioned harmonies real things exhibit piecemeal.

HOW TO STUDY

First study science, and then follow with practice based on science.

The painter who draws by practice and judgment of the eye without the use of reason is like the mirror that reproduces within itself all the objects which are set opposite to it without knowledge of the same.

The youth ought first to learn perspective, then the proportions of everything, then he should learn from the hand of a good master in order to accustom himself to good limbs; then from nature in order to confirm for himself the reasons for what he has learned; then for a time he should study the works of different masters; then make it a habit to practice and work at his art.

THE REQUISITES OF PAINTING

The first requisite of painting is that the bodies which it represents should appear in relief, and that the scenes which surround them with effects of distance should seem to enter into the plane in which the picture is produced by means of the three parts of perspective, namely, the diminution in the distinctness of the form of bodies, the diminution in their size, and the diminution in their color […].

The second requisite of painting is that the actions should be appropriate and have a variety in the figures, so that the men may not look as though they were brothers.

THE PAINTER MUST KNOW ANATOMY

It is a necessary thing for the painter, in order to be able to fashion the limbs correctly in the positions and actions which they can represent in the nude, to know the anatomy of the sinews, bones, muscles, and tendons in order to know, in the various different movements and impulses, which sinew or muscle is the cause of each movement, and to make only these prominent and thickened, and not the others all over the limb, as do many who, in order to appear great draftsmen, make

their nudes wooden and without grace, so that it seems rather as if you were looking at a sack of nuts than a human form or at a bundle of radishes rather than the muscles of nudes.

PROPORTIONS OF THE HUMAN FIGURE

From the chin to the starting of the hair is a tenth part of the figure.

From the chin to the top of the head is an eighth part.

And from the chin to the nostrils is a third part of the face.

And the same from the nostrils to the eyebrows, and from the eyebrows to the starting of the hair.

If you set your legs so far apart as to take a fourteenth part from your height, and you open and raise your arms until you touch the line of the crown of the head with your middle fingers, you must know that the center of the circle formed by the extremities of the outstretched limbs will be the navel, and the space between the legs will form an equilateral triangle.

The span of a man's outstretched arms is equal to his height.

HOW TO COMPOSE GROUPS OF FIGURES IN HISTORICAL PICTURES

When you have thoroughly learned perspective and have fixed in your memory all the various parts and forms of things, you should often amuse yourself, when you take a walk for recreation, by watching and taking note of the attitudes and actions of men as they walk and dispute, or laugh or come to blows one with another—both their actions and those of the bystanders who either intervene or stand looking on at these things; noting them down with rapid strokes in this way, in a little pocket book, which you ought always to carry with you.

HOW TO REPRESENT AN ANGRY FIGURE

An angry figure should be represented seizing someone by the hair and twisting his head down to the ground, with one knee on his ribs, and with the right arm and fist raised high up; let him have his hair disheveled, his eyebrows knit together, his teeth clenched, the two corners of the mouth arched, and the neck (which is all swollen and extended as he bends over the foe) full of furrows.

MOTIONS OF FIGURES

Never set the heads of your figures straight above the shoulders, but turn them sideways to the right or to the left, even though they may be looking up, or down, or straight forward. Because it is necessary so to design their attitudes that they appear sprightly and awake, and not torpid and sleepy.

CHOICE OF BEAUTIFUL FACES

Methinks it is no small grace in a painter to be able to give a pleasing air to his figures, and whoever is not naturally possessed of this grace may acquire it by study, as opportunity offers, in the following manner. Be on the watch to take the best parts of many beautiful faces, of which the beauty is established rather by general repute than by your own judgment, for you may readily deceive yourself by selecting such faces as bear a resemblance to your own, since it would often seem that such similarities please us.

WHETHER IT IS BETTER TO DRAW IN COMPANY OR ALONE

I say and confirm that it is far better to draw in company than alone for many reasons: the first is that you will be ashamed to be seen among the draftsmen if you are unskillful, and this shame will cause you to study well. In the second place, a feeling of emulation will goad you to try to rank among those who are praised more than yourself, for praise will spur you; a third reason is that you will learn from the methods of such as are abler than you, and if you are abler than the others you will profit by eschewing their faults, and hearing yourself praised will increase your skill.

HOW TO MAKE AN IMAGINARY ANIMAL APPEAR NATURAL

You know that you cannot make any animal without it having its limbs such that each bears some resemblance to that of some one of the other animals. If, therefore, you wish to make one of your imaginary animals appear natural— let us suppose it to be a dragon—take for its head that of a mastiff or setter, for its eyes those of a cat, for its ears those of a porcupine, for its nose that of a greyhound, with eyebrows of a lion, the temples of an old cock, and the neck of a water tortoise.

HOW TO PORTRAY FACES GIVING THEM CHARM OF LIGHT AND SHADE

Very great charm of light and shade is to be found in the faces of those who sit in the doors of dark houses. The eyes of the observer see the shaded part of such faces darkened by the shade of the house, and the illuminated part of them brightened by the luminosity of the atmosphere. From this intensification of light ad shadow the faces gain relief, for the illuminated part has almost imperceptible shadows and the shaded part has almost imperceptible lights. This manner of treating and intensifying light and shadow adds much to the beauty of faces.

COLORS

The color of the object illuminated partakes of the color of that which illuminated it [...].
The medium that is between the eye and the object

seen transforms the object into its own color. So the blueness of the atmosphere causes the distant mountains to seem blue; red glass causes everything that the eye sees through it to seem red.

The surface of every opaque body shares in the color of the surrounding objects.

SHADOWS

Since white is not a color but is capable of becoming the recipient of every color, when a white object is seen in the open air all its shadows are blue [...].

The shadows of verdure always approximate to blue, and so it is with every shadow of every other thing, and they tend to this color more entirely when they are farther distant from the eye, and less in proportion as they are nearer.

The shadow of flesh should be of burnt *terra verde*.

THE MIRROR IS THE MASTER OF PAINTERS

When you wish to see whether the general effect of your picture corresponds with that of the object presented by nature, take a mirror and set it so that it reflects the actual thing, and then compare the reflection with your picture and consider carefully whether the subject of the two images is in conformity with both, studying especially the mirror.

OF THE LIFE OF THE PAINTER IN HIS STUDIO

The painter or draftsman ought to be solitary, in order that the well-being of the body may not sap the vigor of the mind.

ADVICE TO THE PAINTER

O painter, take care lest the greed for gain prove a stronger incentive than renown in art, for to gain this renown is a far greater thing than is the renown of riches.

*A*n excerpt from Giorgio Vasari's Lives of the Artists.

LIFE OF LEONARDO DA VINCI
FLORENTINE PAINTER AND SCULPTOR, 1452–1519

In the normal course of events many men and women are born with various remarkable qualities and talents; but occasionally, in a way that transcends nature, a single person is marvellously endowed by heaven with beauty, grace, and talent in such abundance that he leaves other men far behind, all his actions seem inspired, and indeed everything he does clearly comes from God rather than from human art.

Everyone acknowledged that this was true of Leonardo da Vinci, an artist of outstanding physical beauty who displayed infinite grace in everything he did and who cultivated his genius so brilliantly that all problems he studied he solved with ease. He possessed great strength and dexterity; he was a man of regal spirit and tremendous breadth of mind; and his name became so famous that not only was he esteemed during his lifetime but his reputation endured and became even greater after his death.

This marvellous and divinely inspired Leonardo was the son of Piero da Vinci. He would have been very proficient at his early lessons if he had not been so volatile and unstable; for he was always setting himself to learn many things only to abandon them almost immediately. Thus he began to learn arithmetic, and after a few months he had made so much progress that he used to baffle his master with the questions and problems that he raised. For a little while he attended to music, and then he very soon resolved to play the lyre, for he was naturally of an elevated and refined disposition; and with this instrument he accompanied his own charming and improvised singing. All the same, for all his other enter-

prises Leonardo never ceased drawing and working in relief, pursuits which best suited his temperament.

Realizing this, and considering the quality of his son's intelligence, Piero one day took some of Leonardo's drawings to Andrea del Verrocchio (who was a close friend of his) and earnestly begged him to say whether it would be profitable for the boy to study design.[1] Andrea was amazed to see what extraordinary beginnings Leonardo had made and he urged Piero to make him study the subject. So Piero arranged for Leonardo to enter Andrea's workshop. The boy was delighted with this decision, and he began to practise not only one branch of the arts but all the branches in which design plays a part. He was marvellously gifted, and he proved himself to be a first-class geometrician in his works as a sculptor and architect. In his youth Leonardo made in clay several heads of women, with smiling faces, of which plaster casts are still being made, as well as some children's heads, executed as if by a mature artist. He also did many architectural drawings both of ground plans and of other elevations, and, while still young, he was the first to propose reducing the Arno to a navigable canal between Pisa and Florence. He made designs for mills, fulling machines, and engines that could be driven by water-power; and as he intended to be a painter by profession he carefully studied drawing from life. Sometimes he made clay models, draping the figures with rags dipped in plaster and then drawing them painstakingly on fine Rheims cloth or prepared linen. These drawings were done in black and white with the point of the brush, and the results were marvellous […]. Besides this, Leonardo did beautiful and detailed drawings on paper which are unrivaled for the perfection of their finish […]. Altogether, his genius was so wonderfully inspired by the grace of God, his powers of expression were so powerfully fed by a willing memory and intellect, and his writing conveyed his ideas so precisely, that his arguments and reasonings confounded the most formidable critics. In addition, he used to make models and plans showing how to excavate and tunnel through mountains without difficulty, so as to pass from one level to another; and he demonstrated how to lift and draw great weights by means of levers, hoists, and winches, and ways of cleansing harbours and using pumps to suck up water from great depths. His brain was always busy on such devices, and one can find drawings of his ideas and experiments scattered among our craftsmen today […]. He also spent a great deal of time in making a pattern of a series of knots, so arranged that the connecting thread can be traced from one end to the other and the complete design fills a round space […].

Leonardo's disposition was so lovable that he commanded everyone's affection. He owned, one might say, nothing and he worked very little, yet he always kept servants as well as horses. These gave him great pleasure as indeed did all the animal creation which he treated with wonderful love and patience. For example, often when he was walking past the places where birds were sold he would pay the price asked, take them from their cages, and let them fly off into the air, giving them back their lost freedom. In return he was so favoured by nature that to whatever he turned his mind or thoughts the results were always inspired and perfect; and his lively and delightful works were incomparably graceful and realistic.

[1] Andrea del Verrocchio (see above), painter and goldsmith, and the chief sculptor in Florence after Donatello's death.

An excerpt from A. Richard Turner's Inventing Leonardo.

DUCAL SERVANT IN MILAN

Vasari would have it that Leonardo brought to Ludovico Sforza, the *de facto* ruler and later Duke of Milan, a gift—a silver lyre that the artist himself had fashioned in the form of a horse's head. There may be some truth to the story, but it hardly accounts for Leonardo's permanent shift of residence. Possibly it had to do with Ludovico's desire to erect a bronze equestrian monument to the glory of his father, the *condottiere* Francesco Sforza. Both father and son were usurpers of legitimate authority in Milan, and any art suggestive of their dynastic continuity and stability would have been all to the point. Equestrian monuments had the authority of antiquity (as with the imperial Marcus Aurelius in Rome and the destroyed *Regisole* at Pavia); and in Francesco's own time, Donatello had made a monument for the outside of the Church of the Santo in Padua, to memorialize the Venetian *condottiere* Erasmo da Narni, called Gattamelata.

It might have been more obvious to Ludovico through his Florentine correspondents than it is to us that Leonardo was just the man for the job. The artist had surely observed, and probably participated in, major metalworking projects by Verrocchio—the Medici tomb in San Lorenzo, the planning for the *Doubting Thomas* group, the bronze *David*. More to the point, Verrocchio had even competed for the equestrian monument to the Venetian *condottiere* Bartolomeo Colleoni, and in 1481 a full-scale, leather-coated wooden model was taking shape in his studio. Equipped with the benefits of Verrocchio's example, and probably well recommended on the highest authority, Leonardo may have seized the opportunity.

Milan in 1481 was considerably larger than Florence (it had a population of 200,000 compared with 65,000). It lay in a plain between the Alps to the north and the river Po to the south, and was flanked by the rivers Adda and Ticino to either side. Water was essential to the commercial transportation and sanitation of the city, and hydraulic engineering to provide the needed canals was a constant preoccupation from the later Middle Ages onward. The waterworks supported a considerable base of manufacturing, including armaments production. In short, the city was highly attractive to anyone interested in problems of technology.

While Milan had indigenous artists and a scattering of humanists, their number and illustriousness could not compare to those in Florence. So it must have been Milan's practical challenges rather than its high culture that led Leonardo there. That he saw things this way is revealed in a letter to Ludovico in which the artist offers his services. The letter is not in Leonardo's hand, had numerous corrections suggestive of a draft, is not dated, and has no addressee, though the salutation "Illustrious Lord" leaves little doubt about the identity of the intended recipient. Despite these uncertainties, most scholars believe—largely on the basis of records of later projects undertaken by Leonardo that seem related to the letter—that the letter substantively reflects his thought.

The letter opens with Leonardo's assurance that he has reviewed the available technology for instruments of war, and implies that he can do better. He goes on to list the accomplishments in his portfolio, from plans for siege bridges to mines and artillery. It is a shameless piece of bravura, for the closest Leonardo probably had come to such accomplishments was familiarity with them in books and manuscripts by others, notably the *De re military* of 1472 by Roberto Valturio, secretary to Sigismondo Malatesta. About halfway into the letter, Leonardo unconsciously reveals his hand by slipping into the future and conditional tenses, and closes by saying he can demonstrate the feasibility of his suggestions in the Ducal Park. Only at the end of the letter does he claim his expertise in the three major arts, suggesting that "the bronze horse may be taken in

hand, which is to the immortal glory and eternal honor of the prince, your happy father of memory."

Given Leonardo's announced agenda, and the participation of Milan in the defense of Ferrara against the Venetians, it is ironic that the first important record of Leonardo's activity in Milan is not as a technologist but as a painter. He shared a commission (dated April 25, 1483) for an altarpiece for the Chapel of the Confraternity of the Conception in San Francesco Grande (since destroyed), with two local artists, the brothers Evangelista and Ambrogio de' Predis. Leonardo was responsible for the central panel, commonly known as the *Virgin of the Rocks*, which featured the Madonna and Child, young Saint John, and an angel.

There are two very similar surviving versions of the composition—one in the Louvre in Paris and another in the National Gallery in London. The latter picture is traceable to the chapel itself, yet most scholars believe that it was made later than the picture in Paris. The common working hypotheses put forth to resolve this dilemma suggest the Paris picture (1483–86) was the original altarpiece for the chapel, but as some later point was replaced with the London picture (1490s, but perhaps finished as late as 1508) after the first version was given by Ludovico as a diplomatic gift, either to the French king or German emperor, depending on the version of the hypotheses one accepts.

In the Paris picture, the four figures are disposed in a triangle just beyond a chasm in the foreground—a device used to separate the sacred world of the holy figures from the mundane space of the viewer. Mary extends her left hand over the blessing Child, while a kneeling angel draws the viewer's attention to the adorning infant Saint John. Despite the red of the angels garment, this painting, like the *Ginevra de' Benci*, is more a study in tonality than in color. Compared to the *Ginevra*, shadows have deepened, to the degree that light seems a function of shadow rather than vice versa. It is Leonardo's use of sfumato, fully developed. The setting seems

a visionary landscape of stalactite and stalagmite, with heavy air hanging over flowing waters. But if it is a vision, it is grounded in experience of the sort recorded in a drawing from the same years. Scholars have exhaustively searched the Bible and its exegetical literature to discover passages that might explain the juxtaposition of these particular figures with a rocky wilderness, and have come up with some plausible interpretations. But the real significance of Leonardo's visionary topography may lie far deeper.

Soon, painting ceased to be Leonardo's chief concern. There are about a half dozen additional pictures from his first stay in Milan, including several portraits attributed to him, the most elegant—and most surely by his hand—being the *Woman with an Ermine* (probably a portrait of Ludovico's mistress Cecilia Gallerani), the Paris version of the *Virgin of the Rocks*, and of course *The Last Supper*.

It is not known when Leonardo began to keep an extensive written and illustrated record of his works, nor what amount of material from the Florentine years has been lost. But barring evidence yet to be discovered, it is likely that Leonardo began keeping notebooks in earnest only in the mid-1480s. His early interest centered on architecture and military technology. A series of drawings from around 1487–90 involve a competition with Bramante and other local architects for the tambour of the Milanese cathedral. In June 1490 he was in Pavia to consult on work for the cathedral with Sienese architect Francesco di Giorgio, whose treatise on architecture Leonardo annotated.

In Pavia he came to know one of the better libraries in Italy. How much Leonardo read and how much he learned by word of mouth is an open question. A 1489 memorandum reads, "Get Messer Fazio to show you about proportionality." "Get the master of arithmetic to show you how to square a circle." "Try to get Vitelone, which is in the library of Pavia, and treats of mathematics." Leonardo was eagerly in search of knowledge, whatever source.

Concise Bibliography

Alberti, Leon Battista. *On Painting.* Trans. Cecil Grayson. New York: Penguin Books, 1991.

Bambach, Carmen C., Alessandro Cecchi, Martin Kemp, Claire Farago, Varena Forcione, Carlo Pedretti, Carlo Vecce, Françoise Viatte, and Linda Wolk-Simon. *Leonardo da Vinci: Master Draftsman.* New Haven: Yale University Press, 2003.

Berenson, Bernard. *Italian Painters of the Renaissance.* 2 vols. London: Phaidon, 1968.

Bramly, Serge. *Leonardo: The Artist and the Man.* London: Penguin Books Ltd., 1994.

Brown, David Alan, Giulio Bora, Maria T. Ficino, and Pietro C. Marani. *The Legacy of Leonardo: Painters in Lombardy, 1480–1530.* Milan: Skira, 1999.

Clark, Kenneth. *Leonardo da Vinci.* New York: Oxford University Press, 2004.

Goldwater, Robert, and Marco Treves, eds. *Artists on Art from the XIV to the XX Century.* New York: Pantheon Books, 1945.

Kemp, Martin. *The Science of Art: Optical Themes in Western Art from Brunelleschi to Seurat.* New Haven: Yale University Press, 1992.

Kemp, Martin, and Margaret Walker. *Leonardo: On Painting.* New Haven: Yale University Press, 2001.

Nicholl, Charles. *Leonardo da Vinci: Flights of the Mind.* New York: Viking Books, 2004.

Turner, A. Richard. *Inventing Leonardo.* Berkeley: University of California Press, 1994.

Vasari, Giorgio. *Lives of the Artists (Volume I).* Trans. George Bull. London: Penguin Books Ltd., 1987.

Vinci, Leonardo da. *The Notebooks of Leonardo da Vinci.* Ed. and trans. Jean Paul Richter 2 vols. New York: Dover, 1970.